BE
STRESS
FREE
AND

Brimming with creative inspiration, how-to projects, and useful information to enrich your everyday life, Quarto Knows is a favorite destination for those pursuing their interests and passions. Visit our site and dig deeper with our books into your area of interest: Quarto Creates, Quarto Cooks, Quarto Homes, Quarto Lives, Quarto Drives, Quarto Explores, Quarto Gifts, or Quarto Kids.

10 9 8 7 6 5 4

ISBN: 978-0-7858-3865-4

Cover art and interior artwork by Angela Porter
Text by Lacy Mucklow, MA, ATR-BC, LPAT, and LCPAT

Printed in China

This book provides general information on various widely known and widely accepted images that tend to evoke feelings of calm and/or reduce stress or anxiety in individuals. However, it should not be relied upon as recommending or promoting any specific diagnosis or method of treatment for a particular condition, and it is not intended as a substitute for medical advice or for direct diagnosis and treatment of a medical condition by a qualified physician. Readers who have questions about a particular condition, possible treatments for that condition, or possible reactions from the condition or its treatment should consult a physician or other qualified healthcare professional.

BE
STRESS
FREE
AND
COLOR

**CHANNEL YOUR WORRIES INTO A
COMFORTING, CREATIVE ACTIVITY**

Lacy Mucklow, MA. ATR-BC, LPAT, LCPAT
Illustrated by Angela Porter

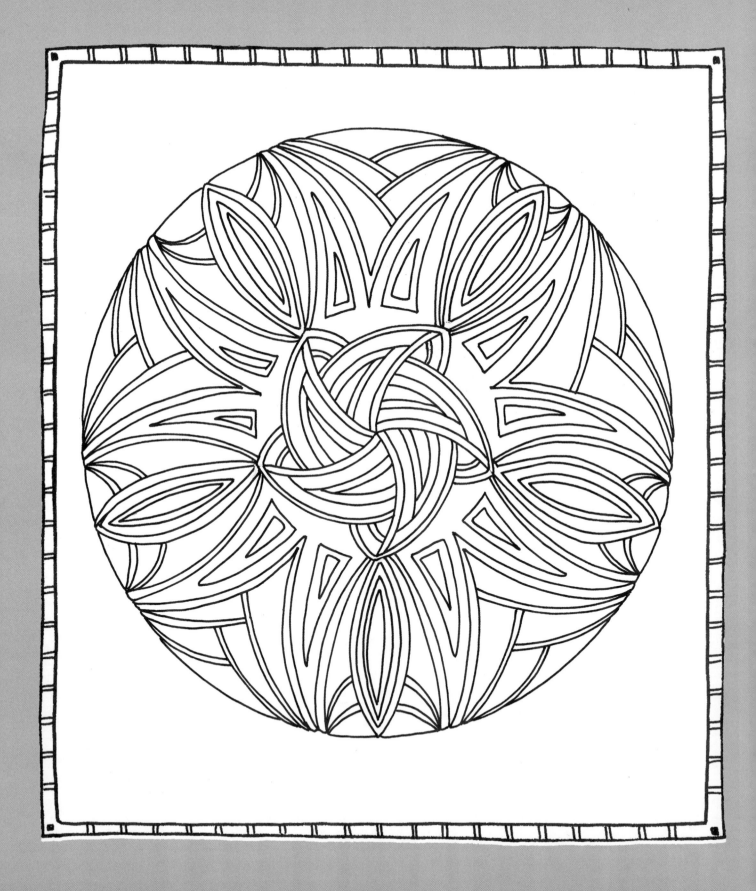

INTRODUCTION

Why create a coloring book for adults? As children, many of us enjoyed coloring our favorite characters or scenes in books with our trusty pack of crayons. But as we got older, added responsibilities came along that pushed aside things we used to do for sheer enjoyment.

One of the great things about coloring is that it is highly successful for everyone—even if you lack artistic instruction or experience—and it can be as nuanced or generalized as the colorer wishes. Having guidelines eases performance anxiety, and being able to add our own colors helps make the experience more personal. The act of coloring can also be meditative in and of itself, bringing about stress relief just through the simple act of picking up a colored pencil or crayon and focusing creativity and thoughts on a single coloring exercise.

Despite what you may have learned about art and color in your lifetime, there is no right or wrong way to use this book; you have the freedom to color it in however you wish in whatever way works best for you. *Be Stress-Free and Color* features designs that tackle seven of the most common stressors experienced by people worldwide: disorganization and chaos, relationships of all kinds, financial difficulties, employment, health concerns, time management, and traveling and commuting. We have named

the stressors here because sometimes even being able to identify the source of your stress can help to start alleviating it. The images included in this book to color have been chosen specifically to serve as positive counters to these stressors. These images—mandalas, geometric designs, fractals, and abstract representations—along with themes or structures can provide a feeling of relief from or empowerment toward the stress. For example, images of symmetry, balance, and stability can help to counter the stress that stems from disorganization and chaos. Themes of connectedness, efficiency, regulation, self-care, growth, strength, well-being, order, positive creativity and outcomes, expansion, new beginnings, problem-solving, love, self-reflection, centering, and clear journeys come through the images to help evoke positive qualities that can manage feelings of anxiety and promote a sense of relaxation from daily and chronic stressors.

We realize that what relieves stress for people can run the gamut even within "universal" categories, so we have included a variety of images within each chapter so at least some of the pieces connect with you personally. The designs are intended for adult sensibility and dexterity rather than for children, and include actual scenes (or variations thereof) of stress-relieving subjects. Many are more abstract in nature so that you may enjoy the intricacy of the patterns themselves, as many of us do. Most importantly, this book is about helping you suspend your mental energies for a short while and hone in on something else that can help promote well-being.

You may find that using this book regularly might be particularly helpful for you, such as beginning your morning with a coloring template to help you set a calm and mindful tone for the day or coloring before going to sleep to help your body and mind to wind down from the day.

Or you may choose to use it as needed, in response to a particularly long day or after excess exposure to one particular stressor.

This book is intended to help bring you to a more relaxed emotional state as a way to help you self-soothe; however, it is not meant to replace the services of a professional therapist if more direct intervention and personal guidance are needed. We hope that you enjoy this book and that it helps you find a way to color yourself stress-free!

COLOR TIP

Cool colors (especially blue, green, and sometimes purple) are considered to have calming qualities, while warmer colors (such as red, oranges, and yellows) have more activating qualities. Bright colors also tend to have more energy, while pastel or tinted colors tend to communicate softer energy. Darker colors or shades usually indicate lower energy. The most important thing to consider when coloring is to determine which pleasant and soothing colors will help you when you need to calm down, and which energetic colors will help you when you want to promote a positive growth or outlook, and then try to incorporate them into your artwork.

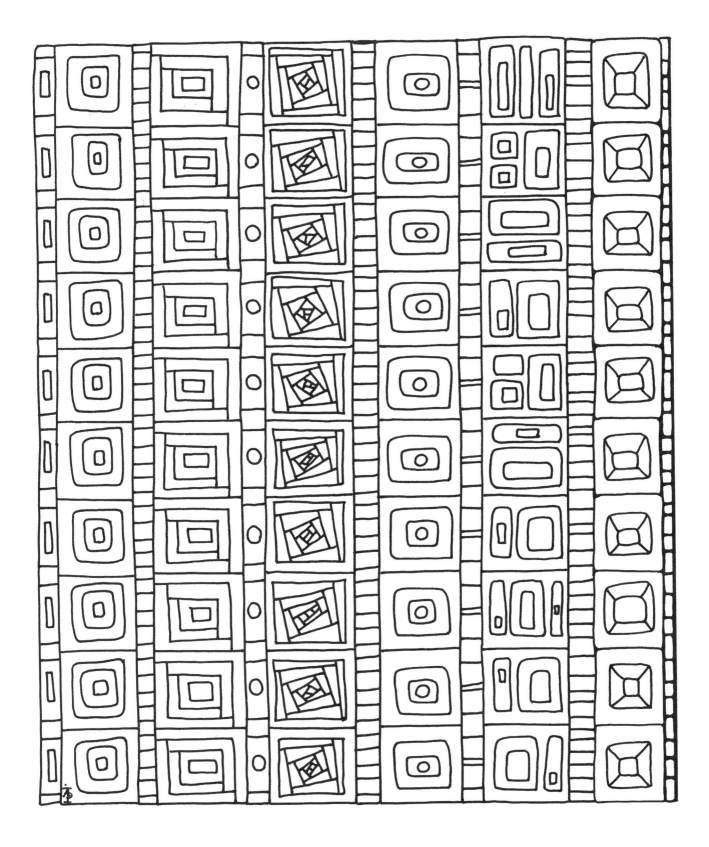

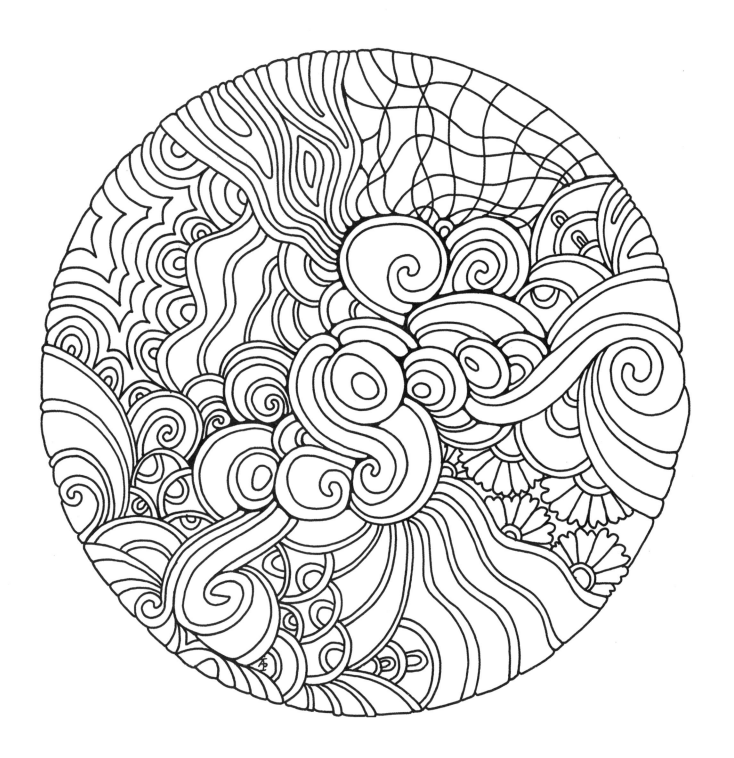

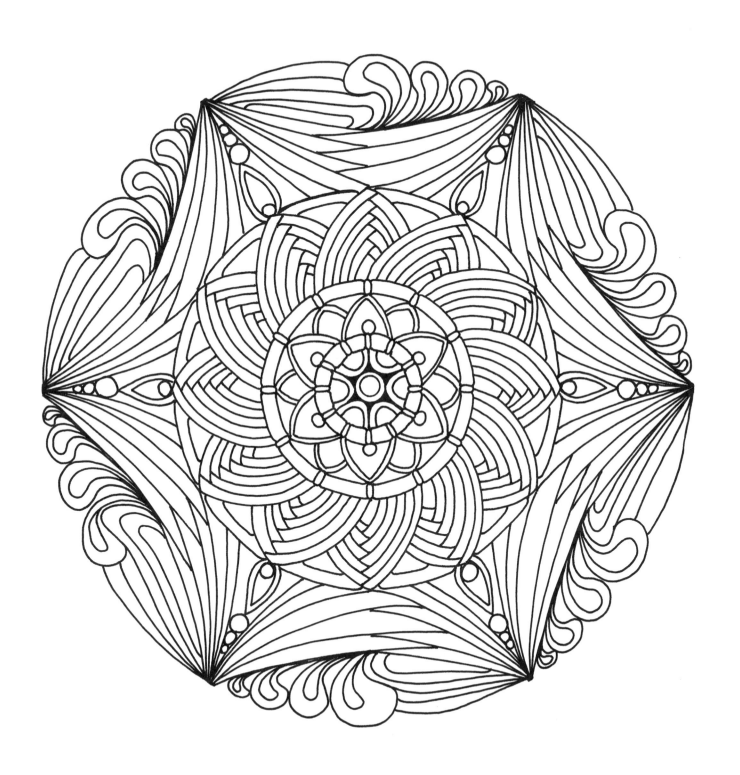

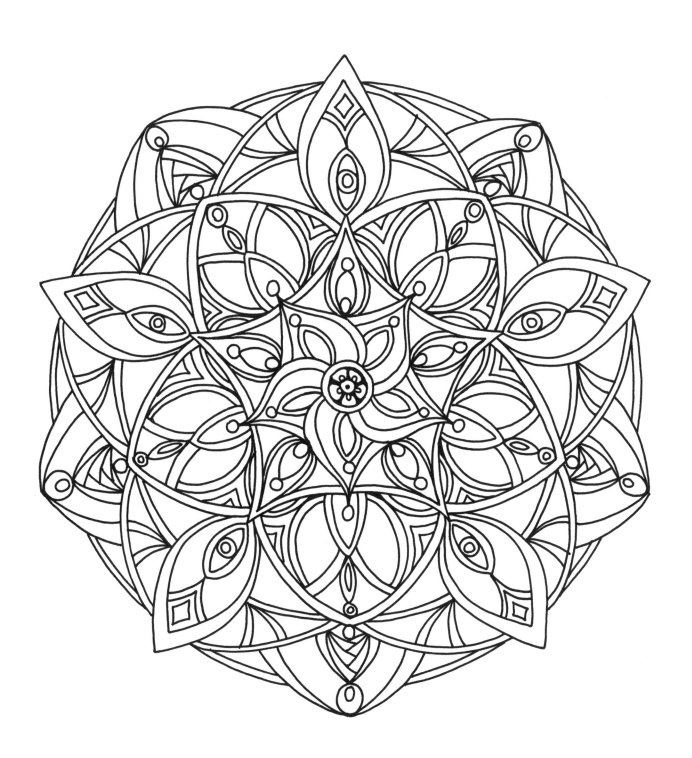

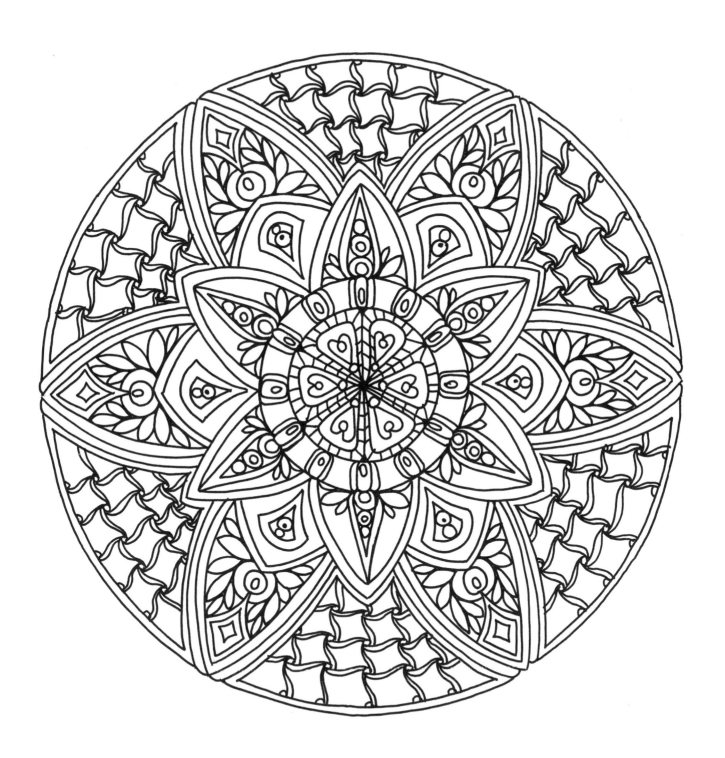

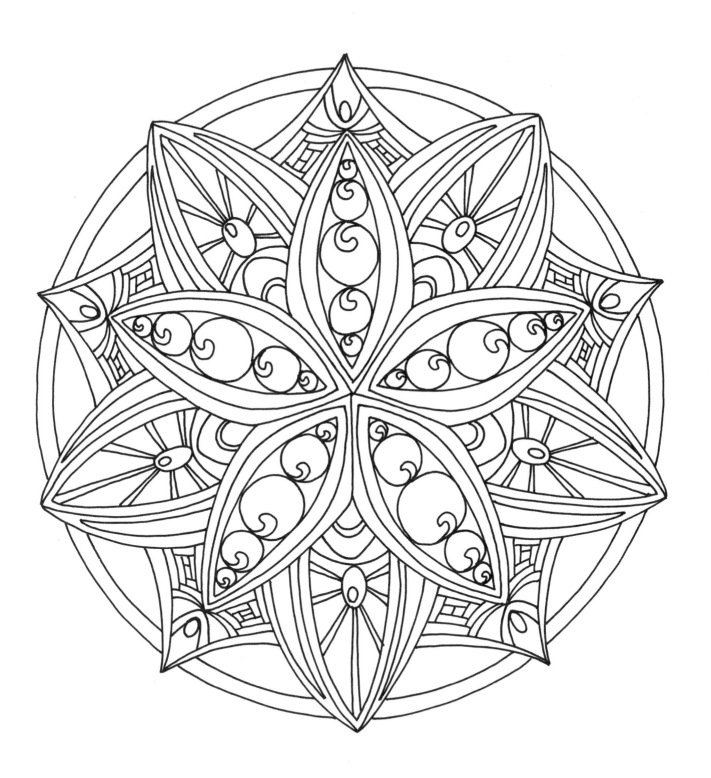

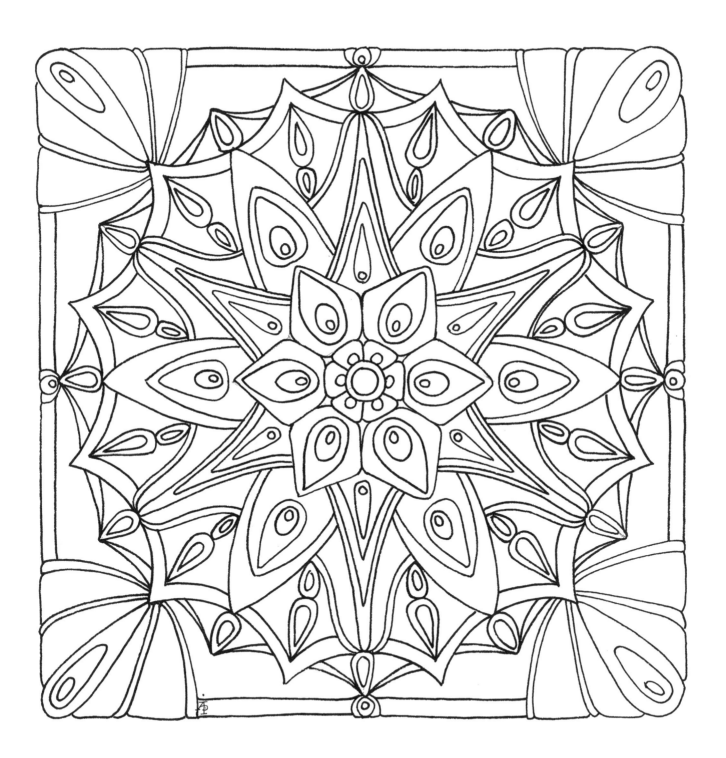

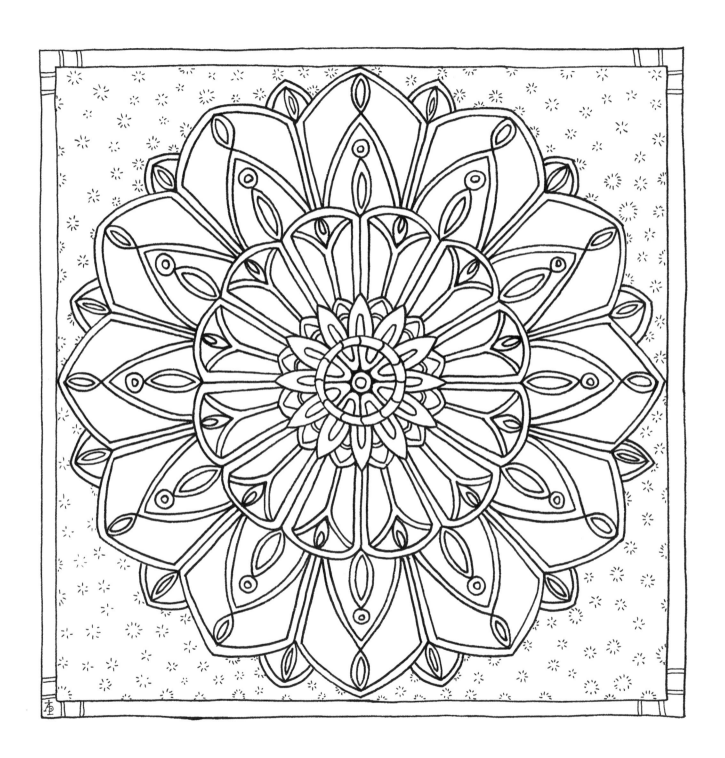

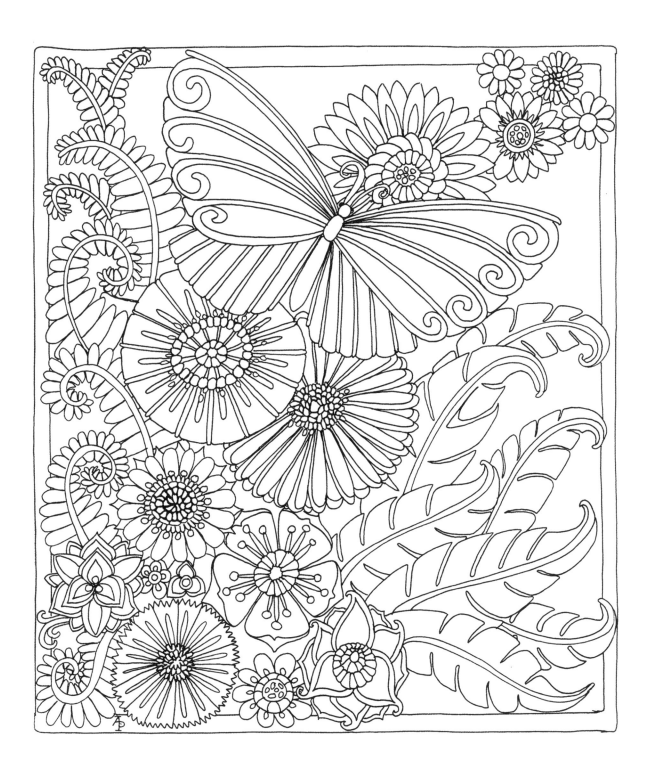

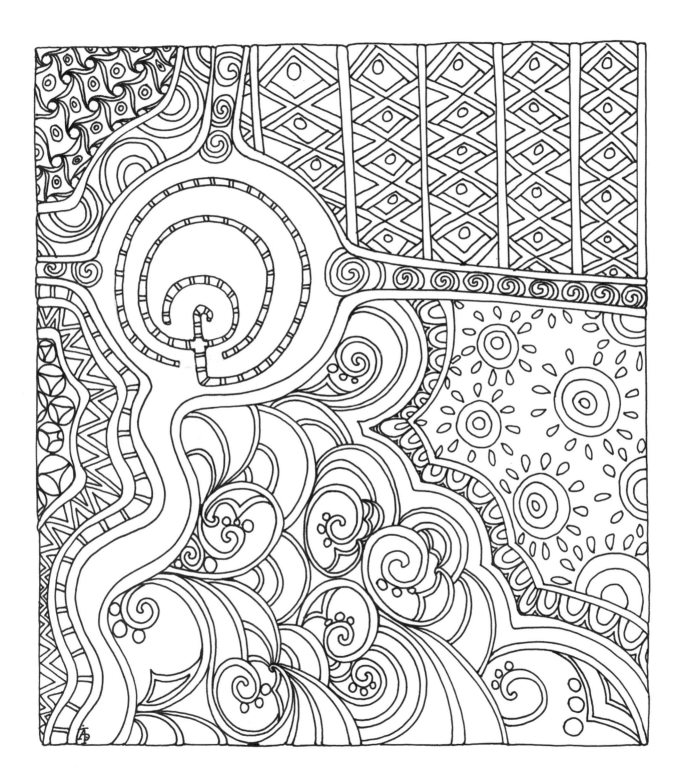

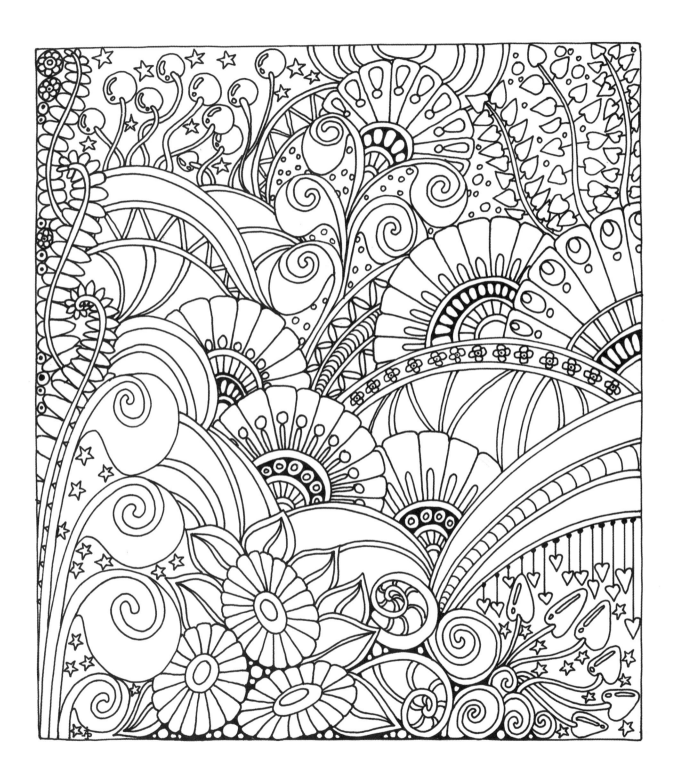

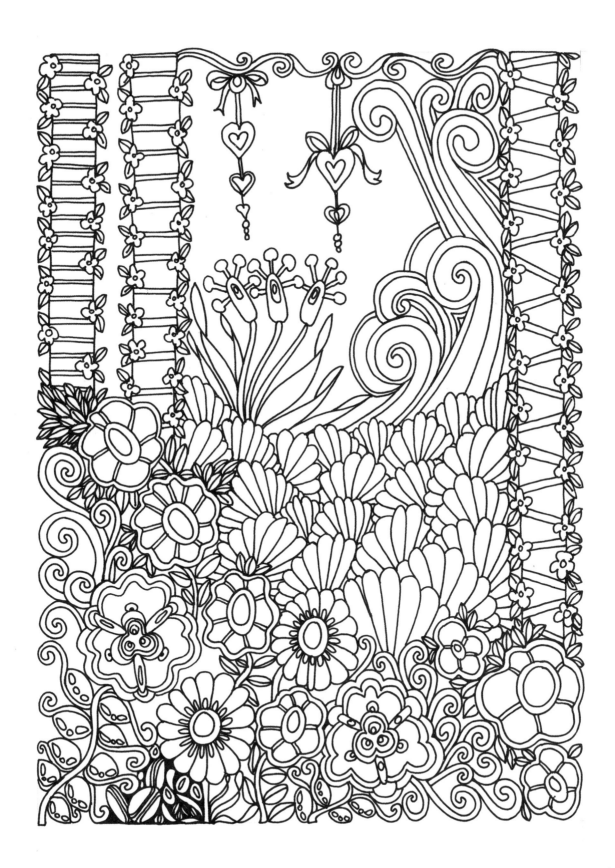

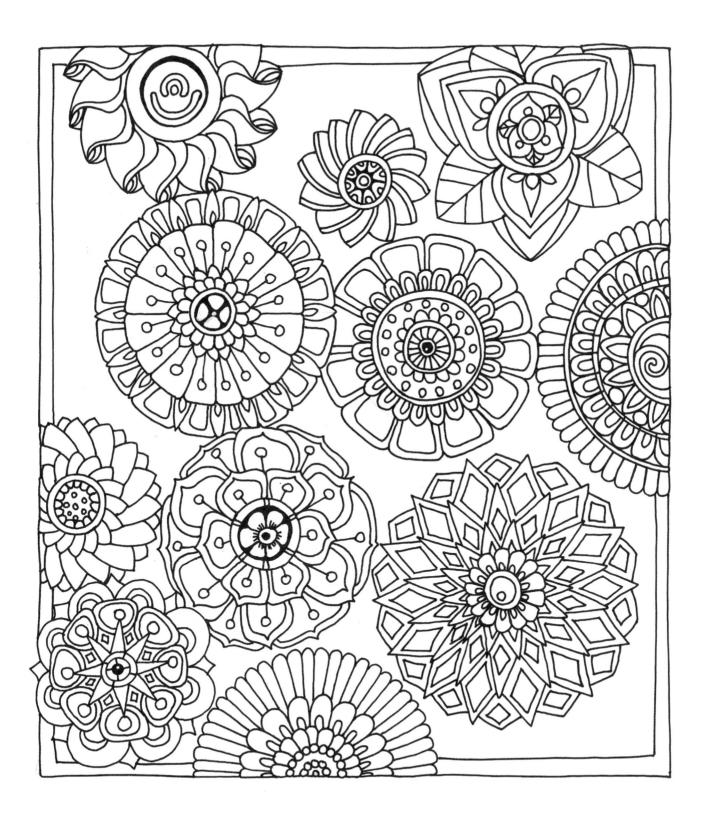

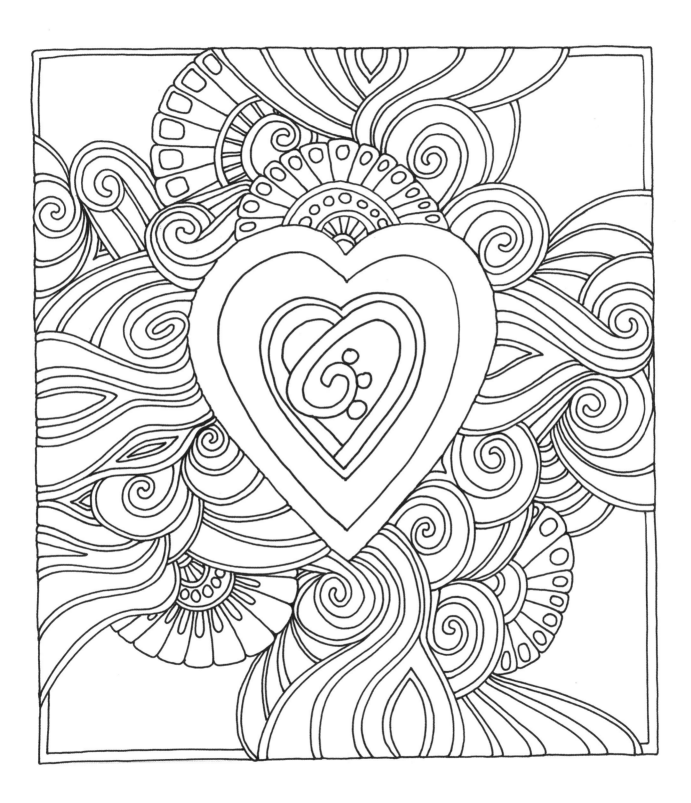

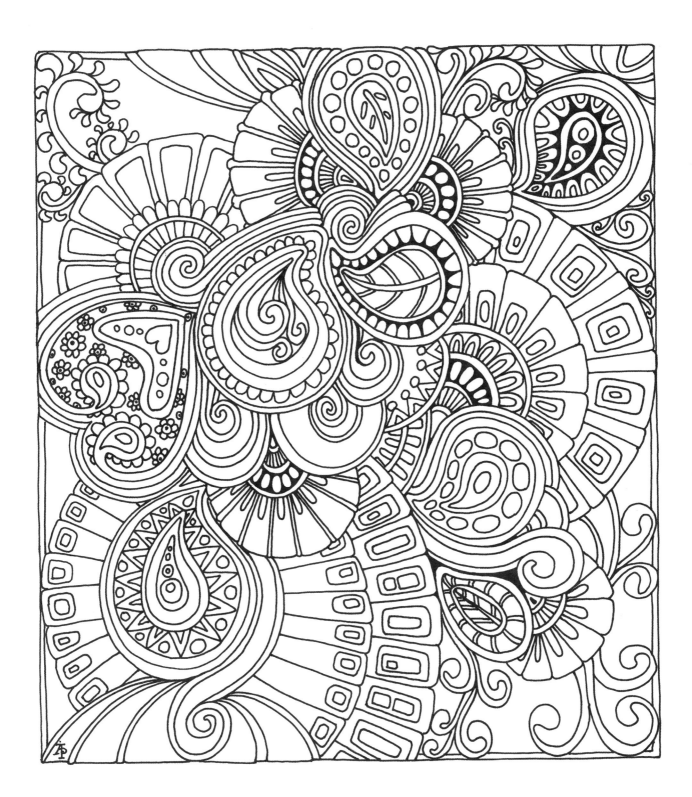

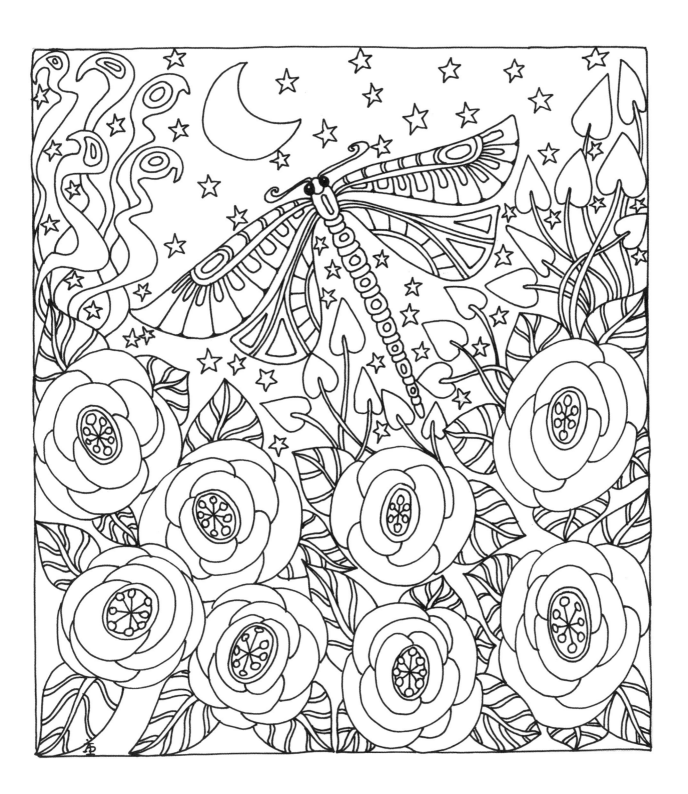

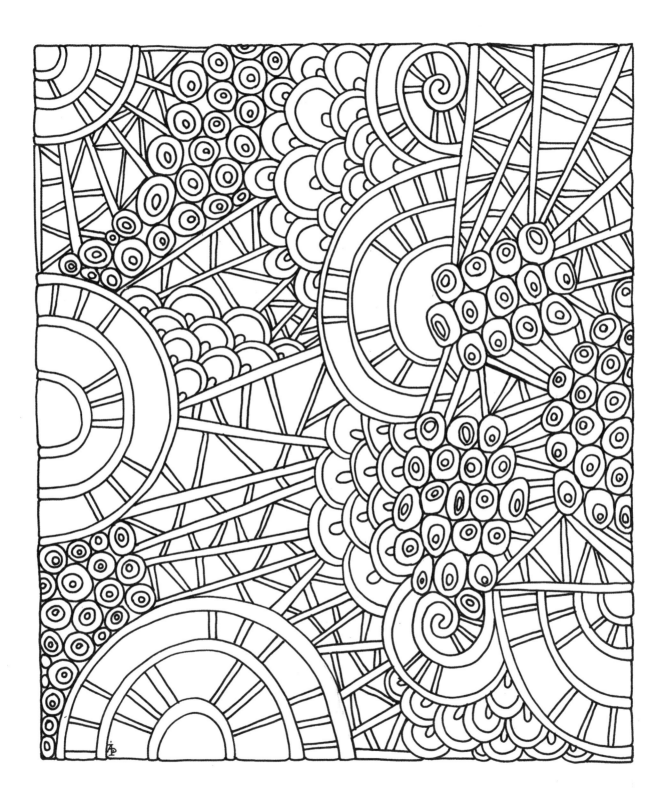

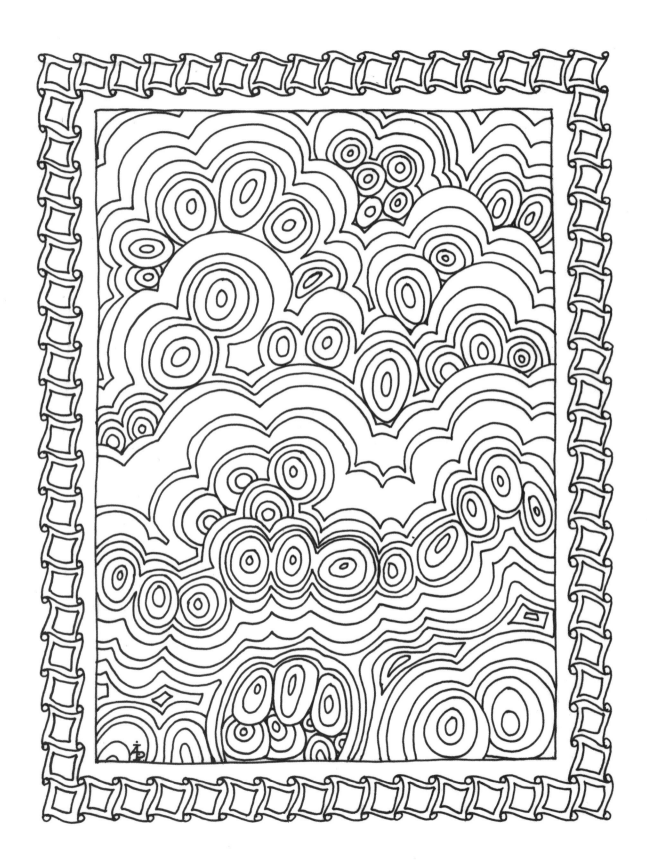

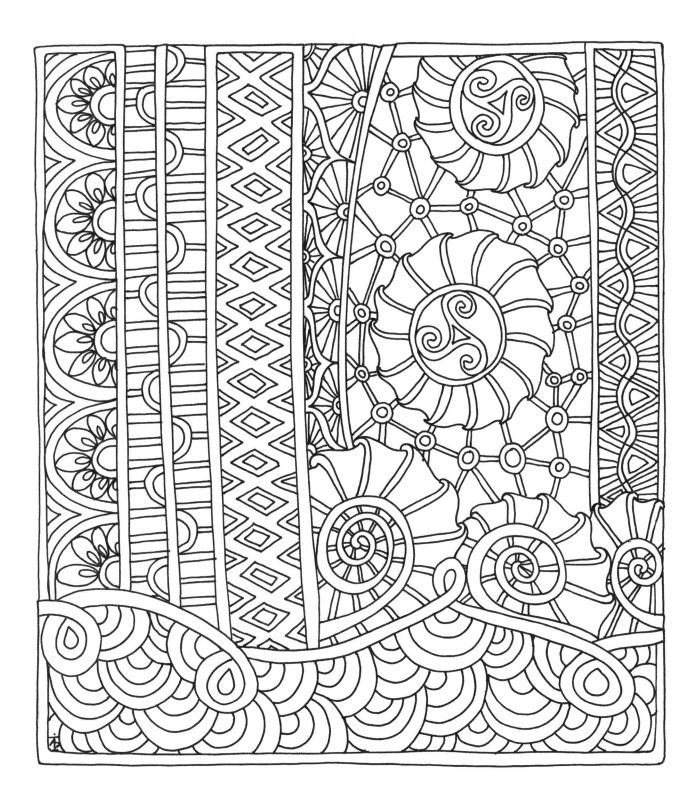

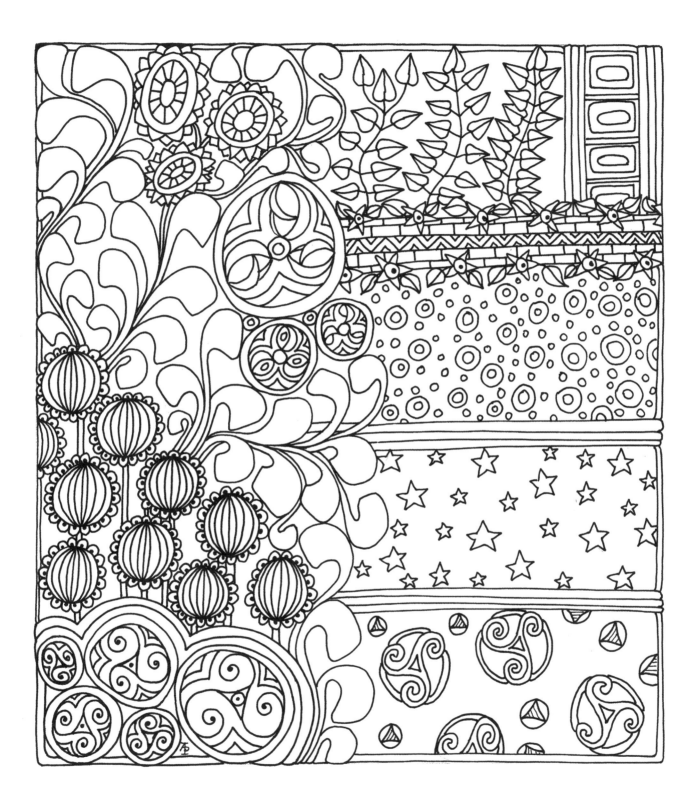

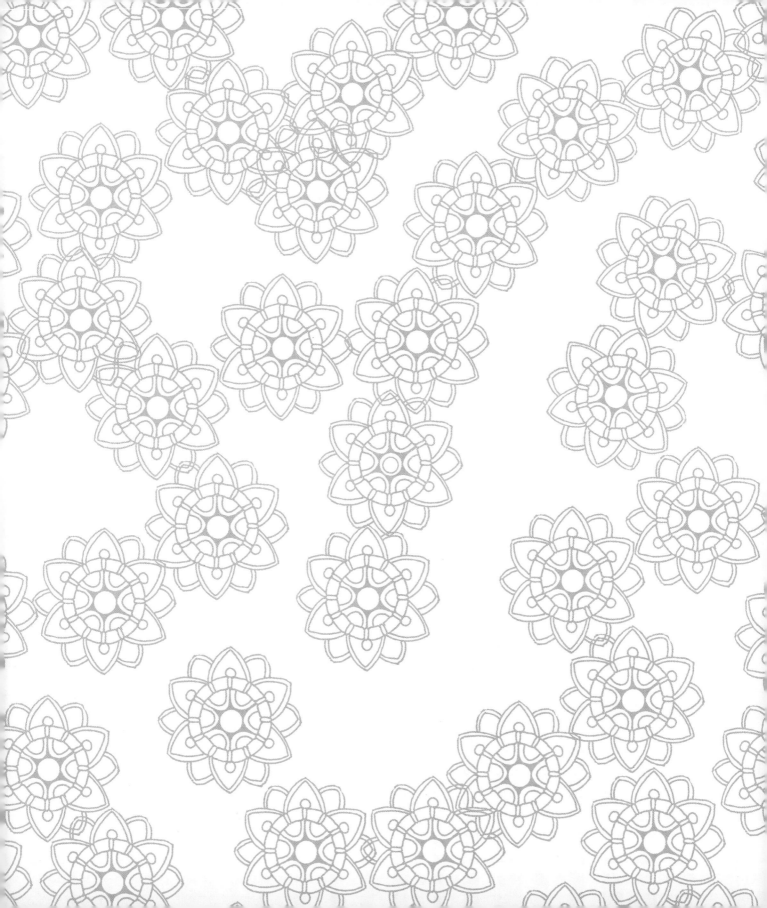

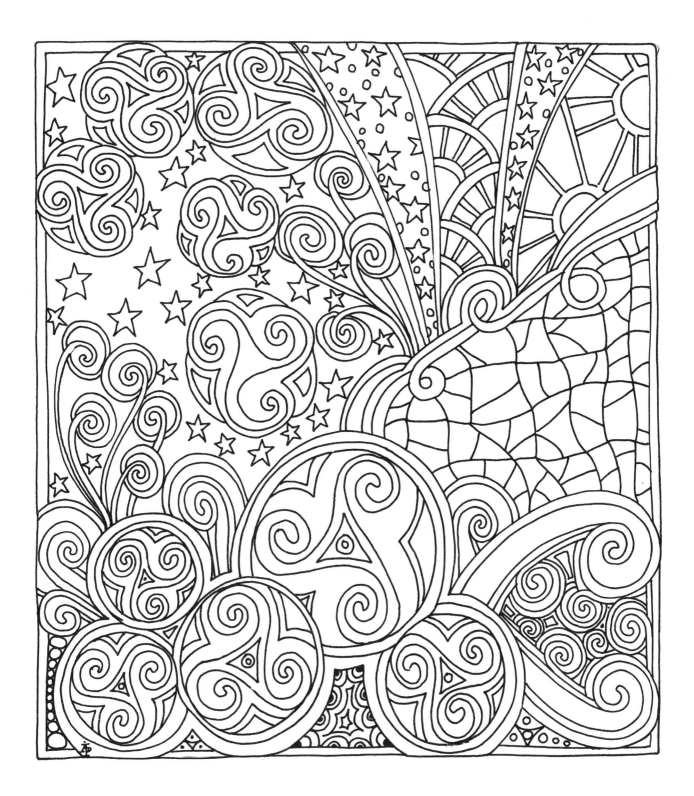

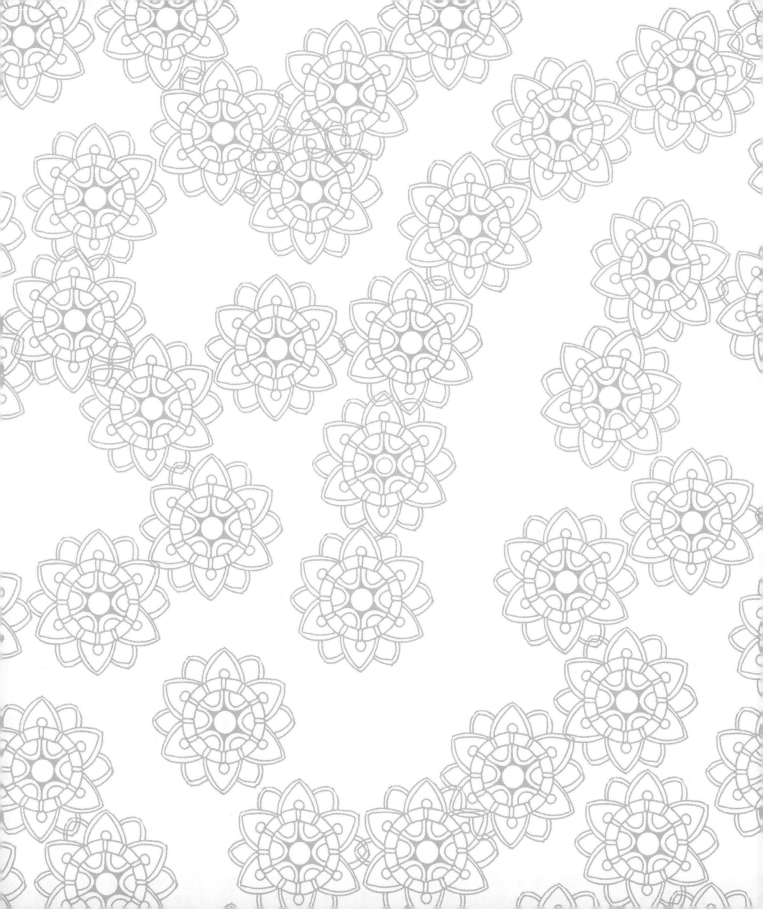

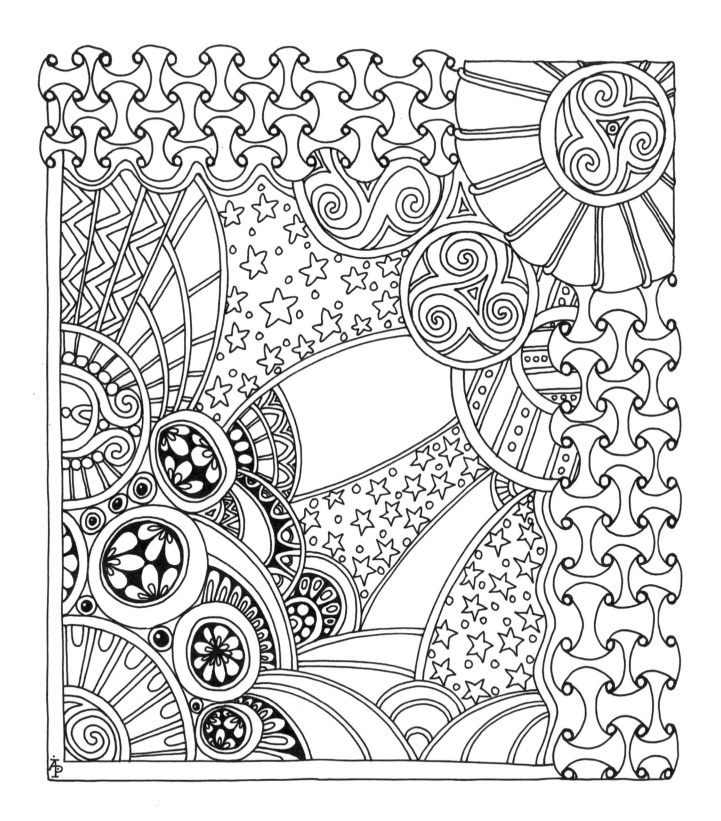

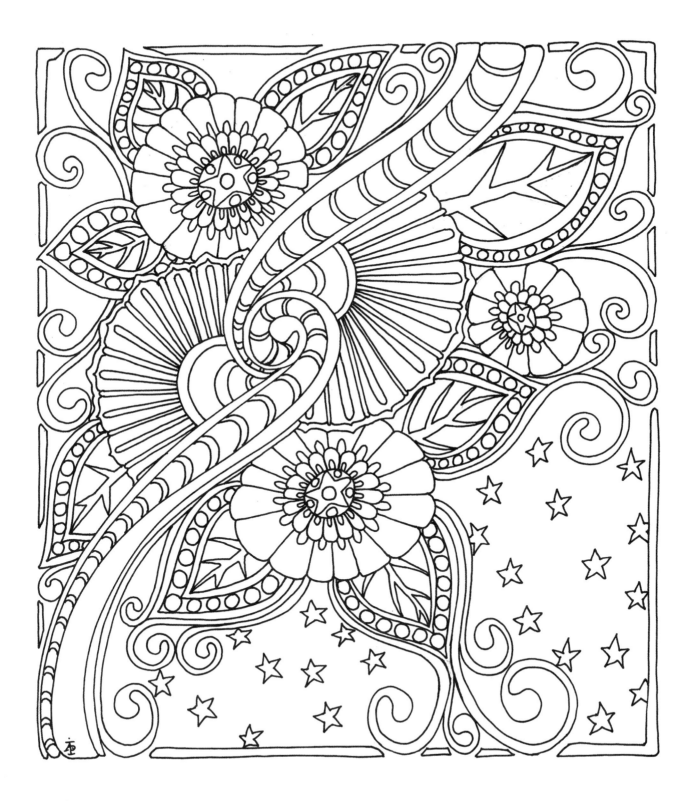

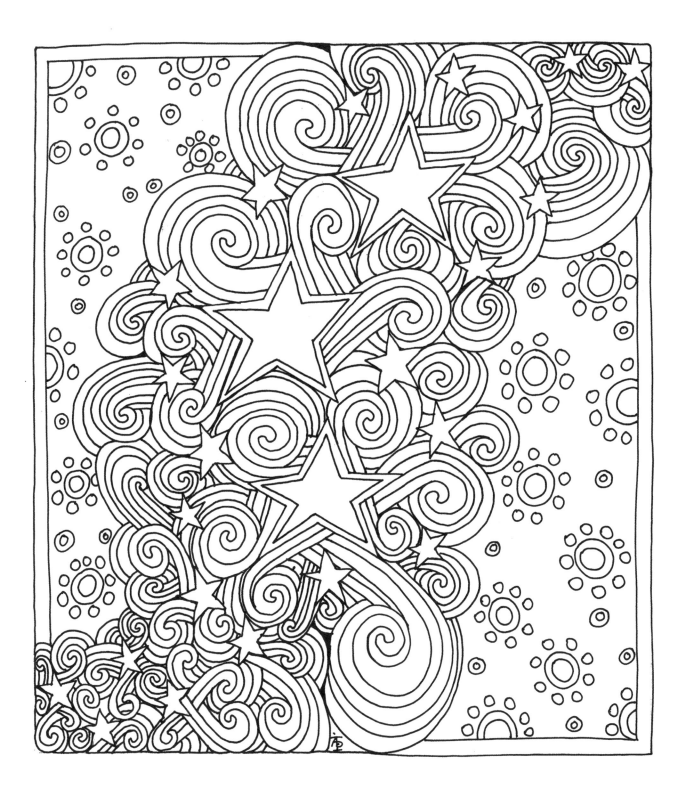

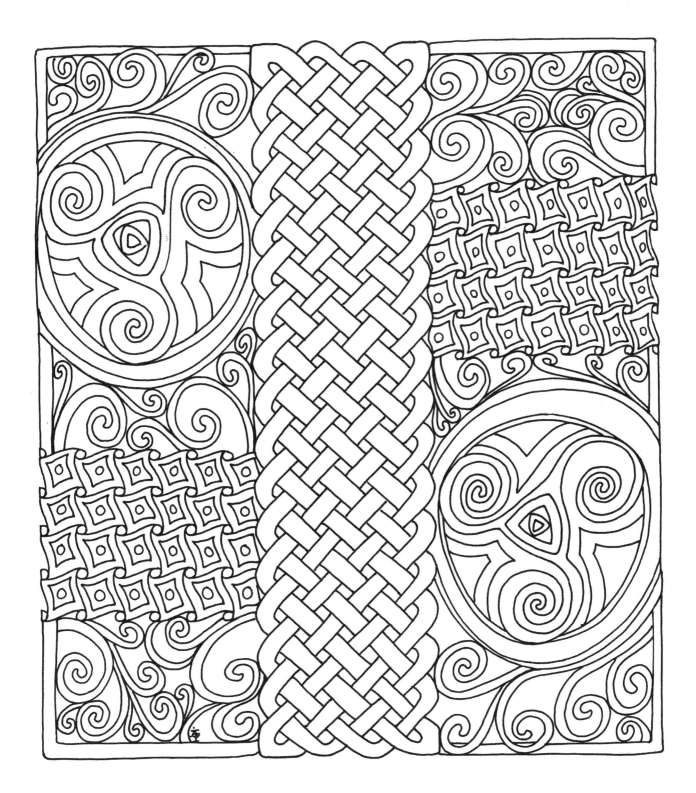

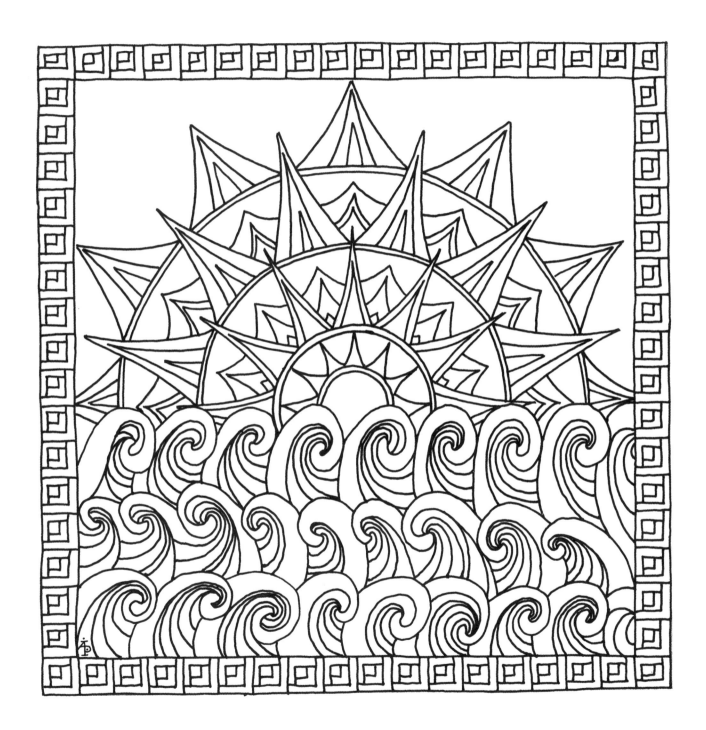

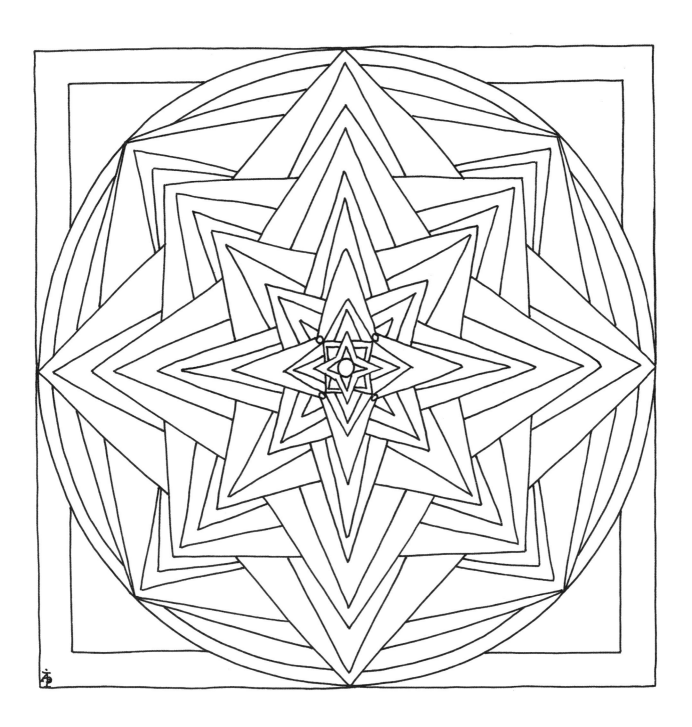

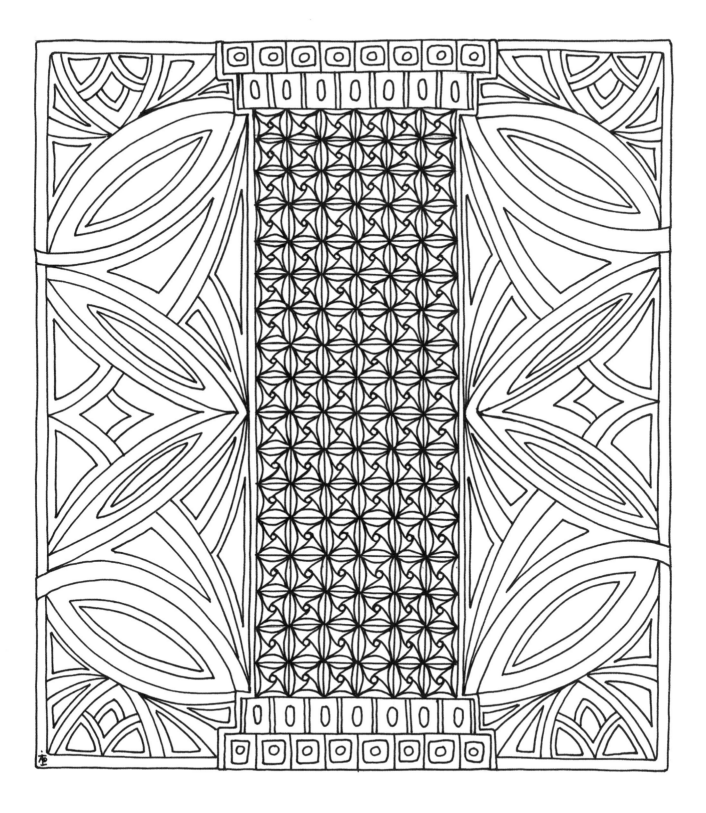

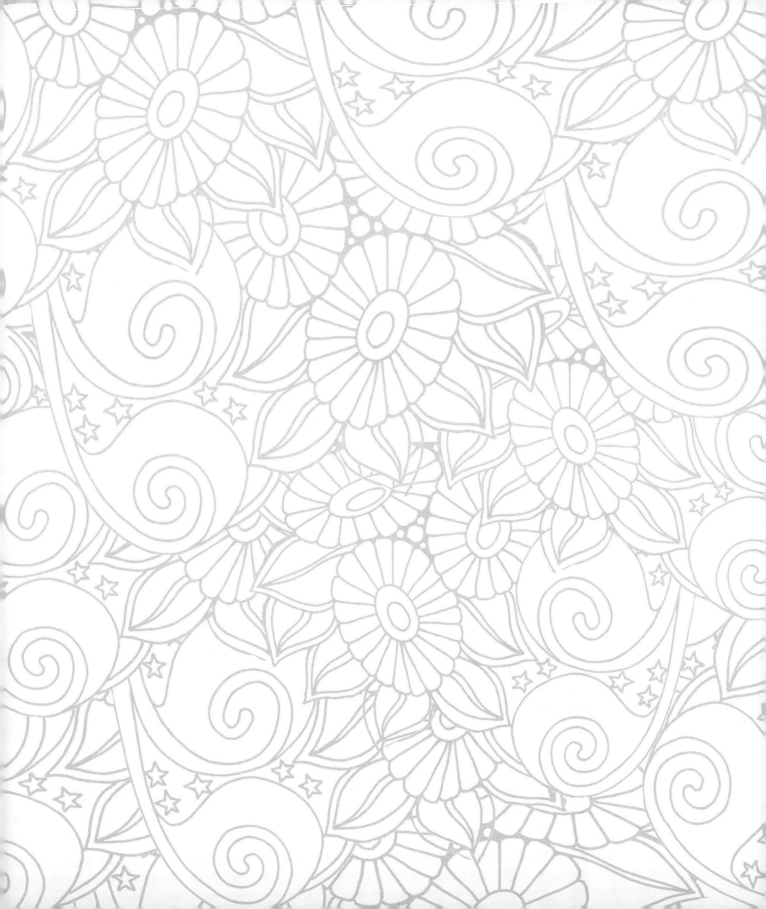

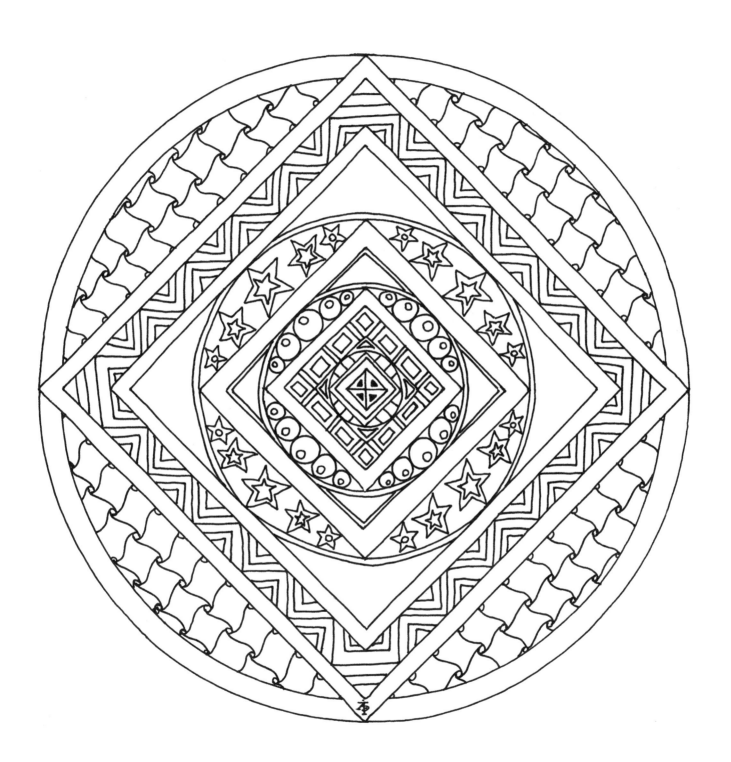

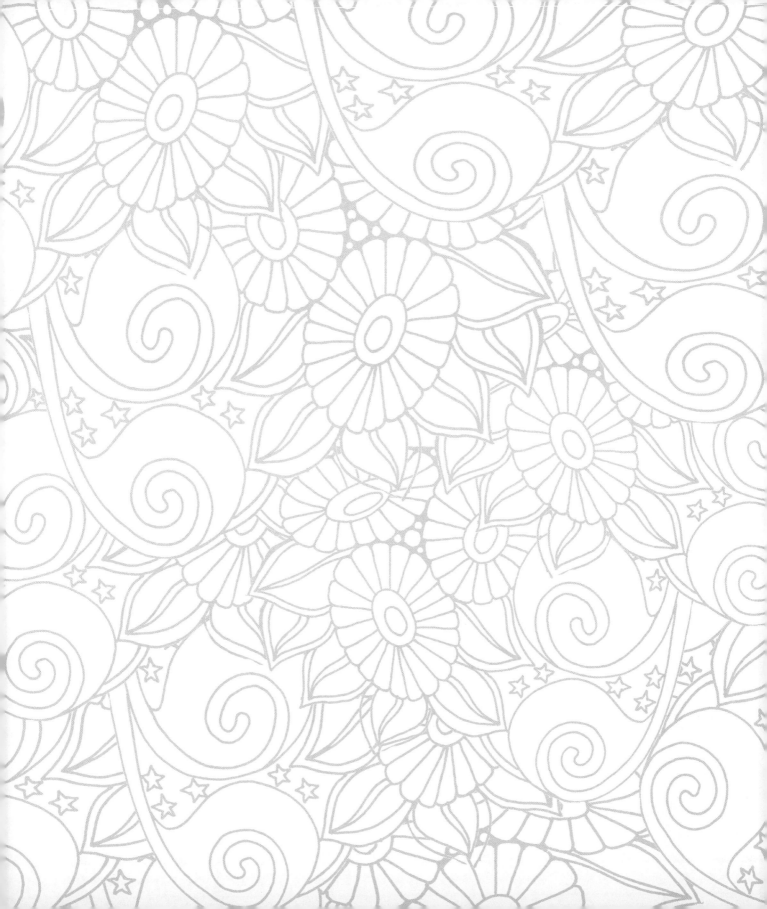

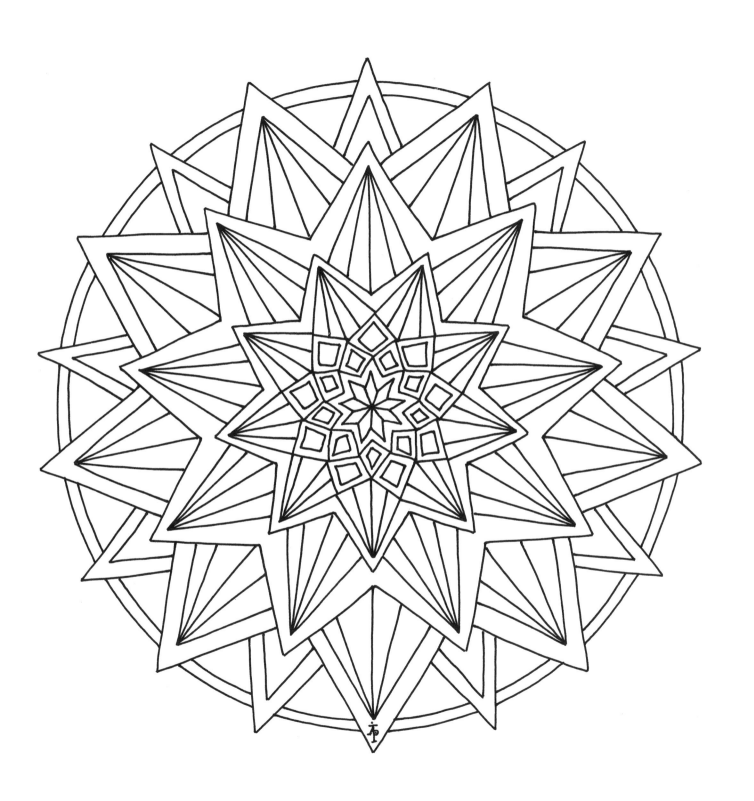

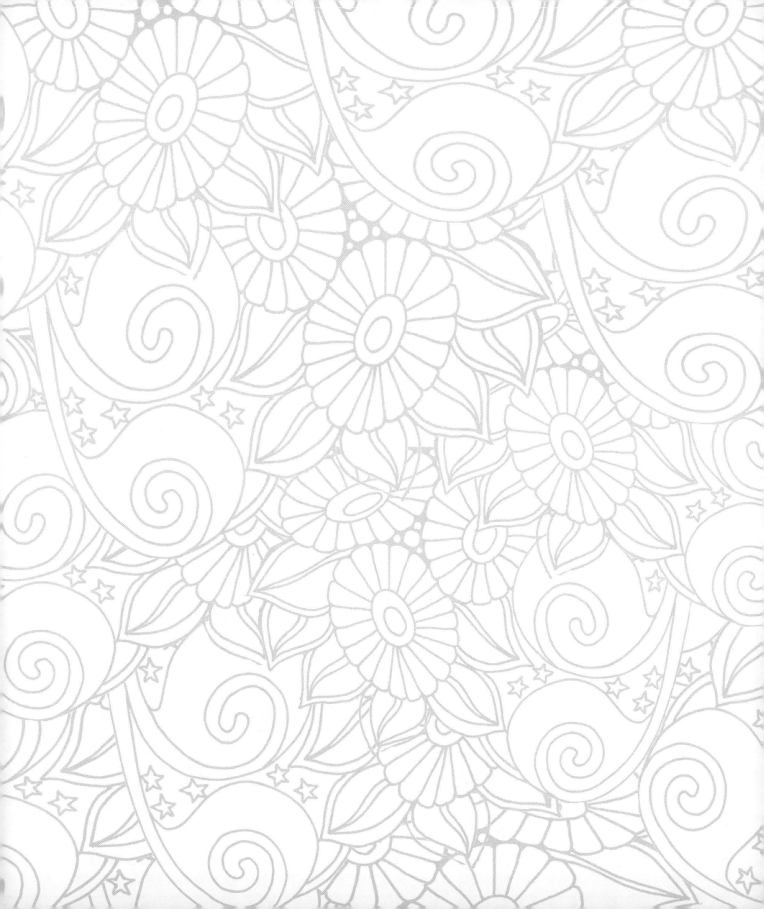

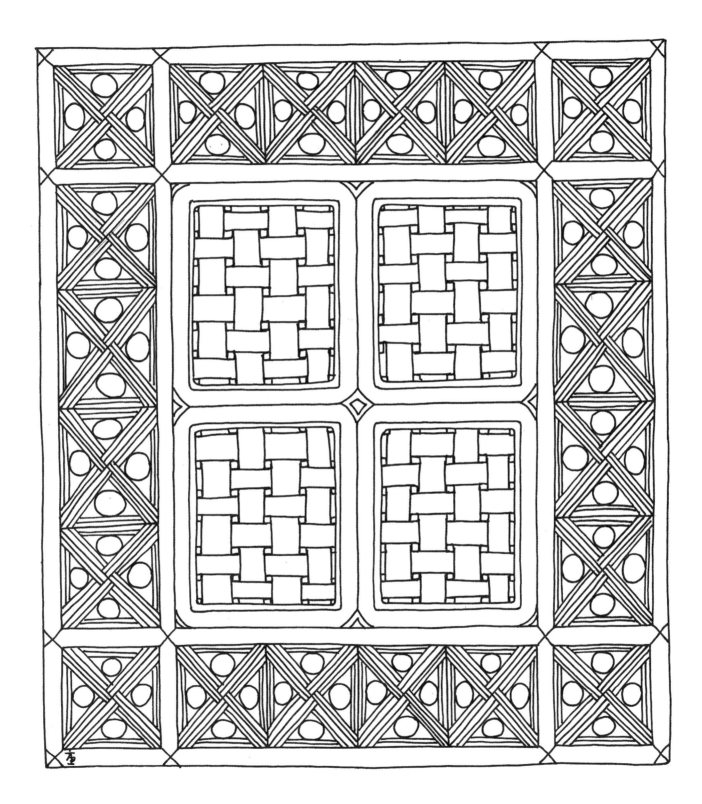

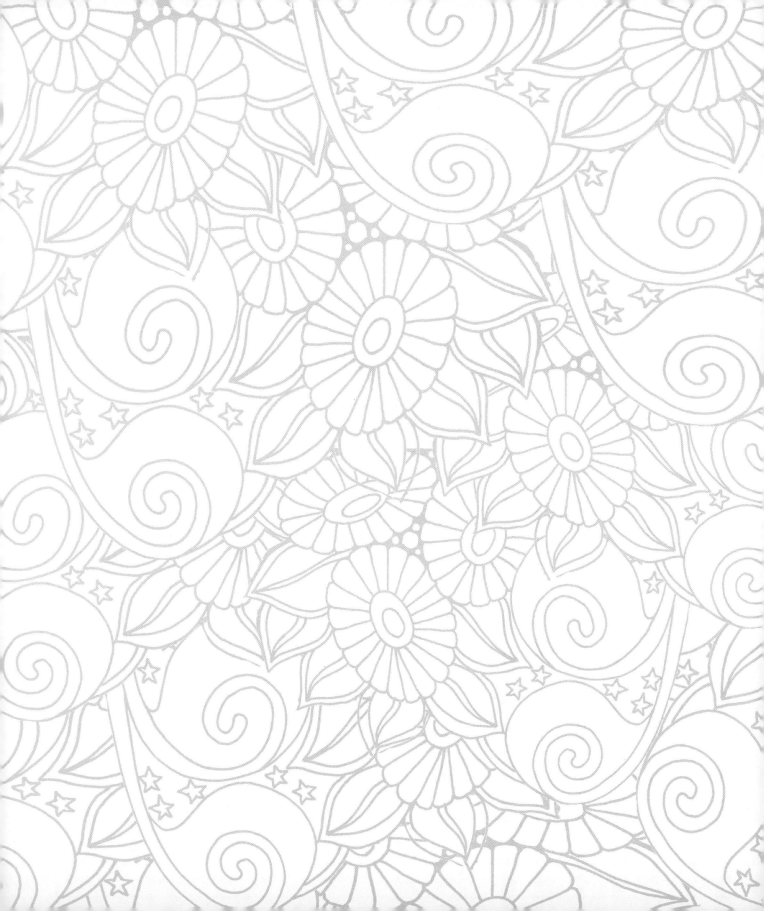

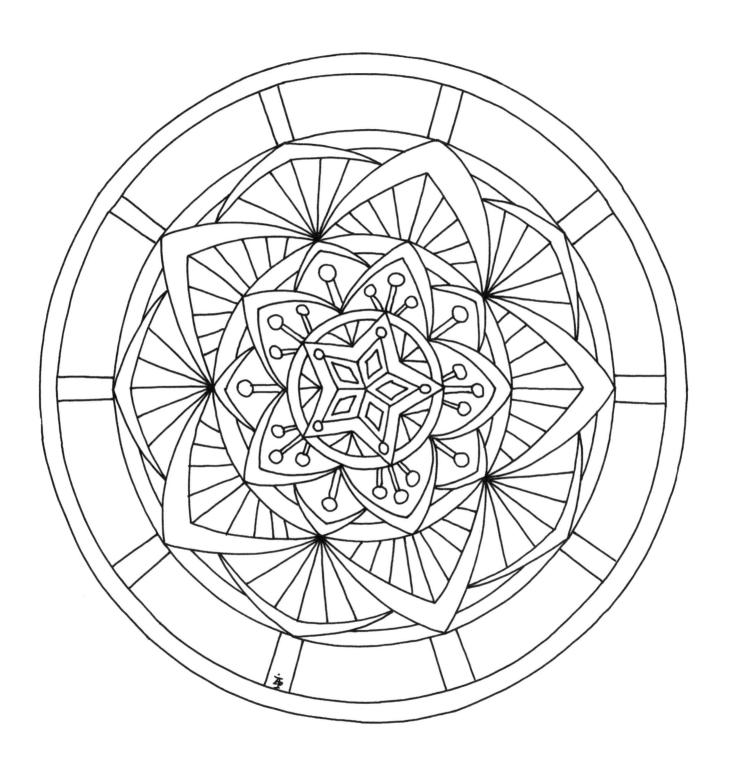

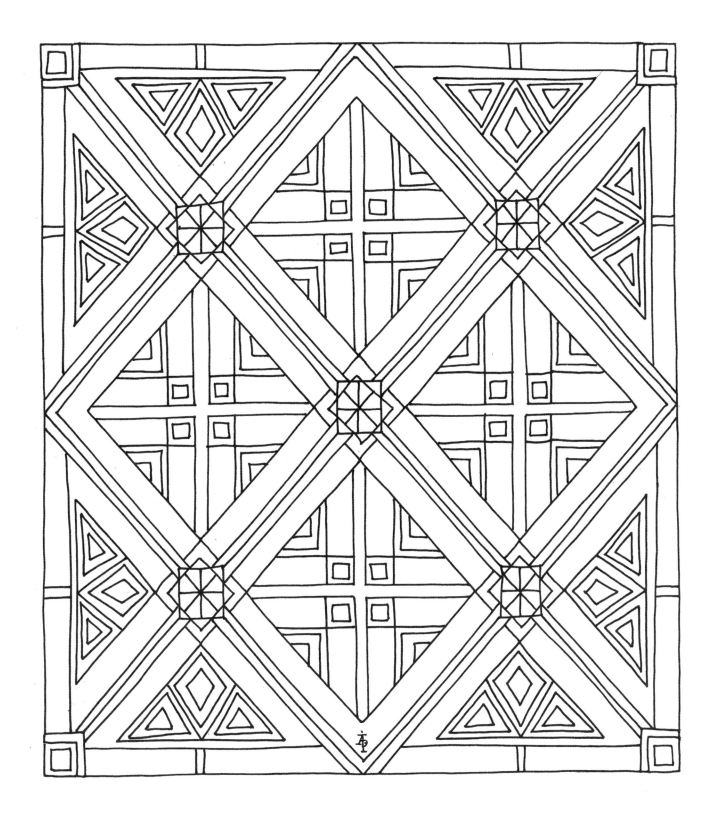

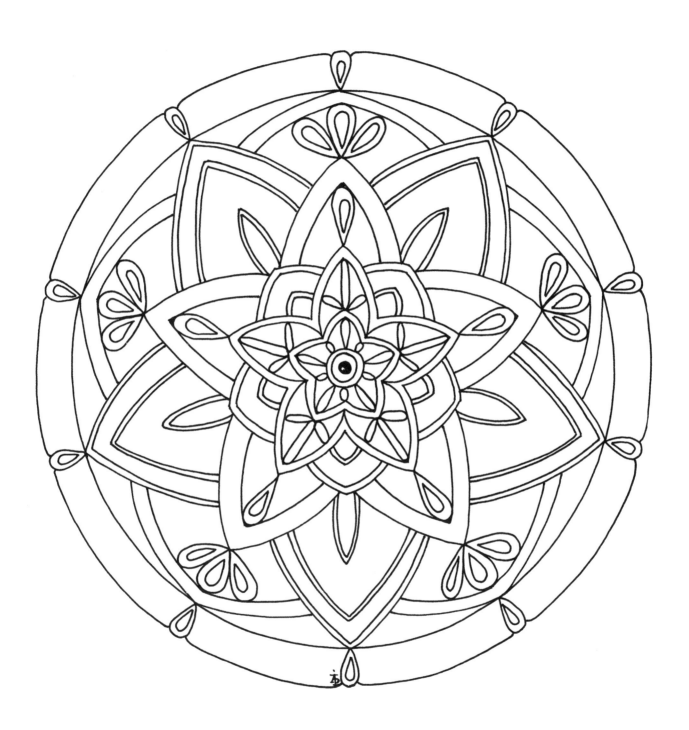

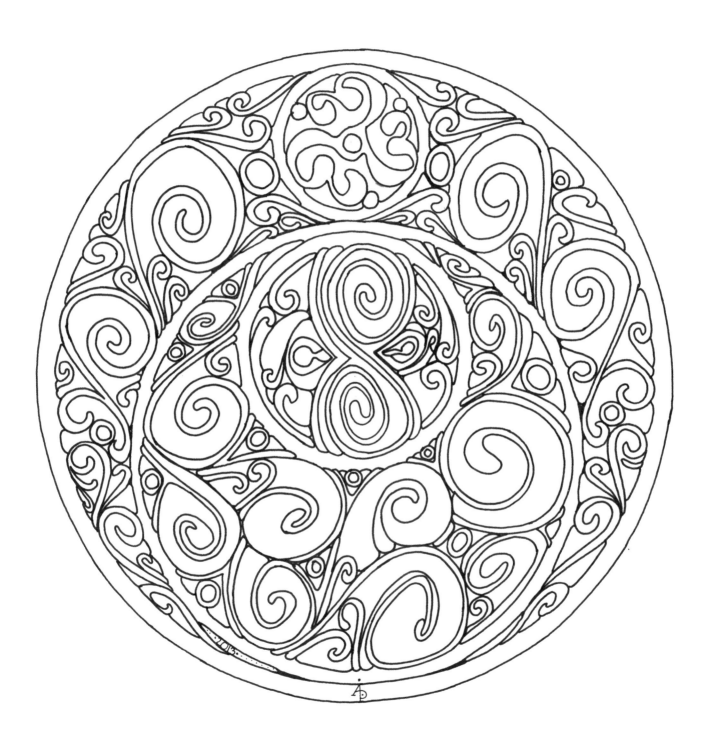

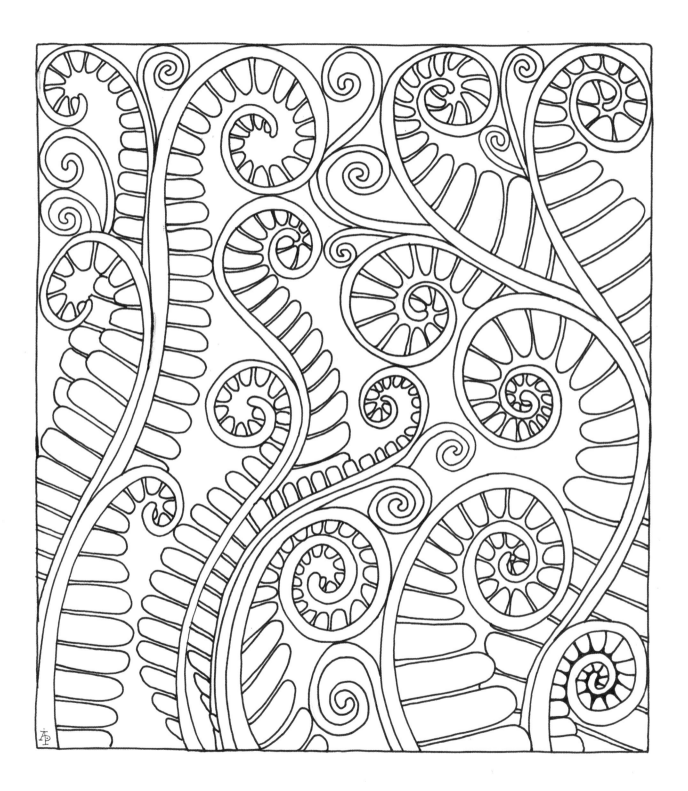

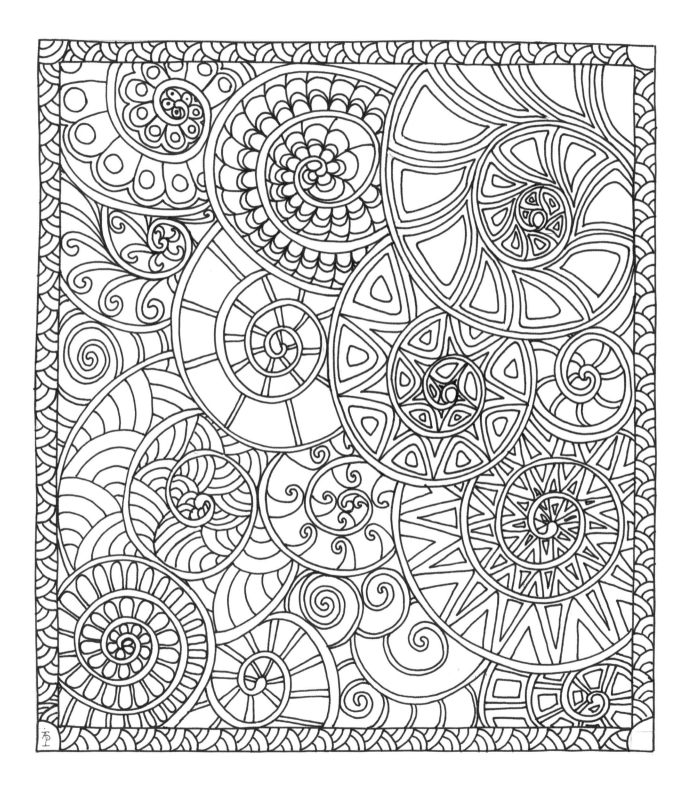

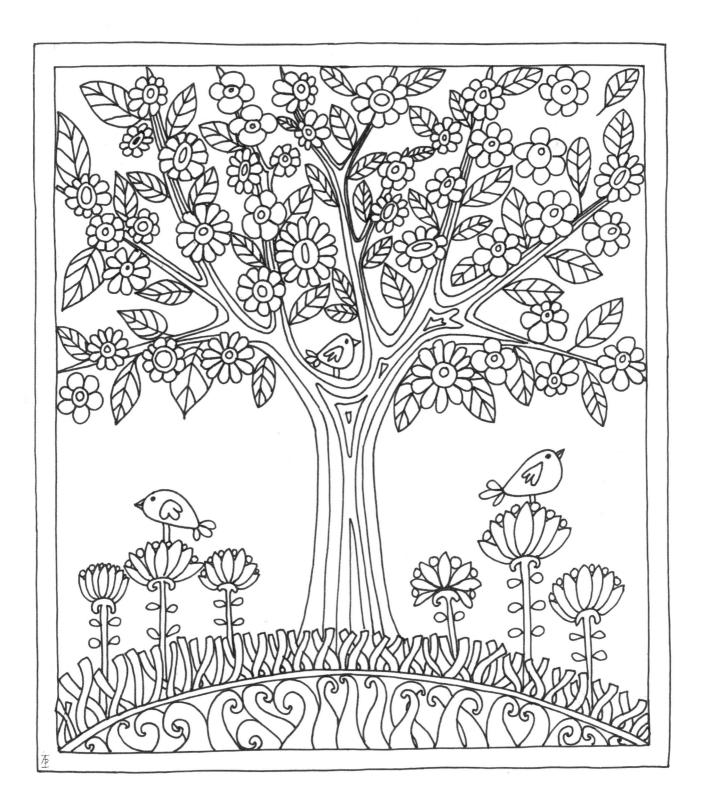

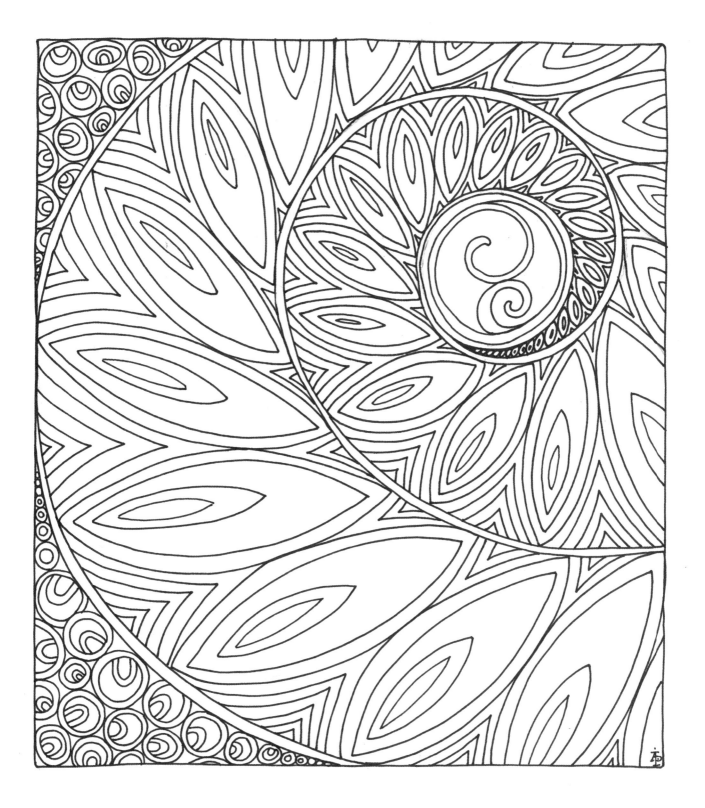

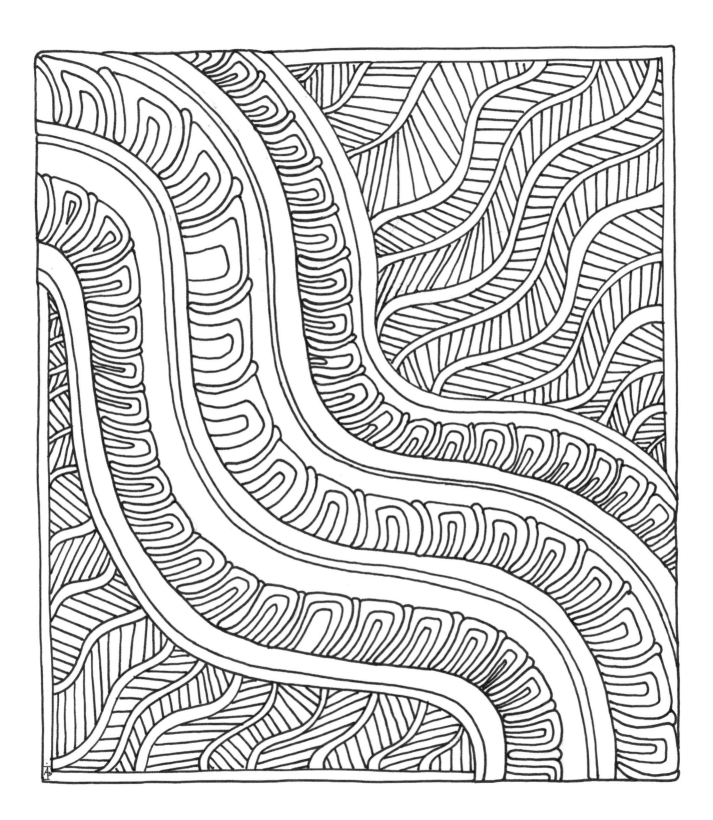

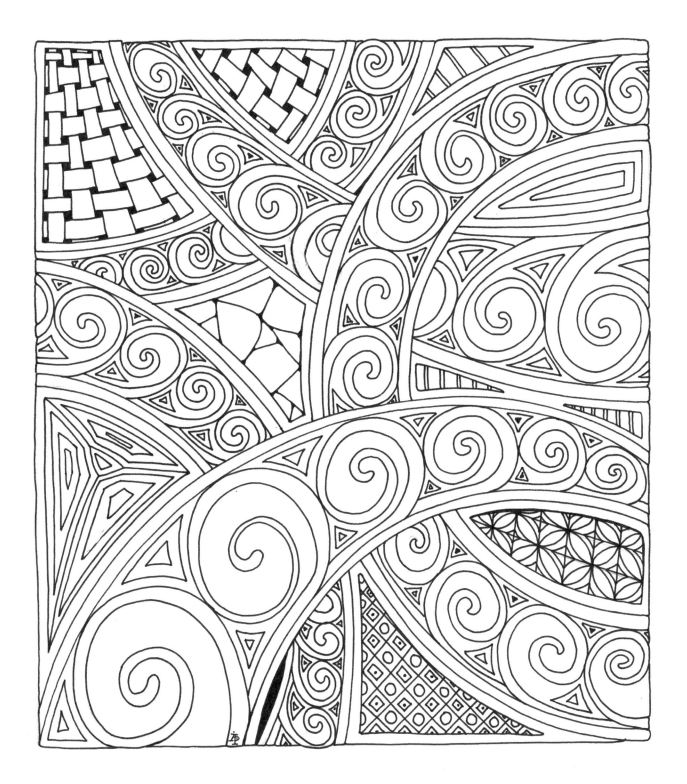

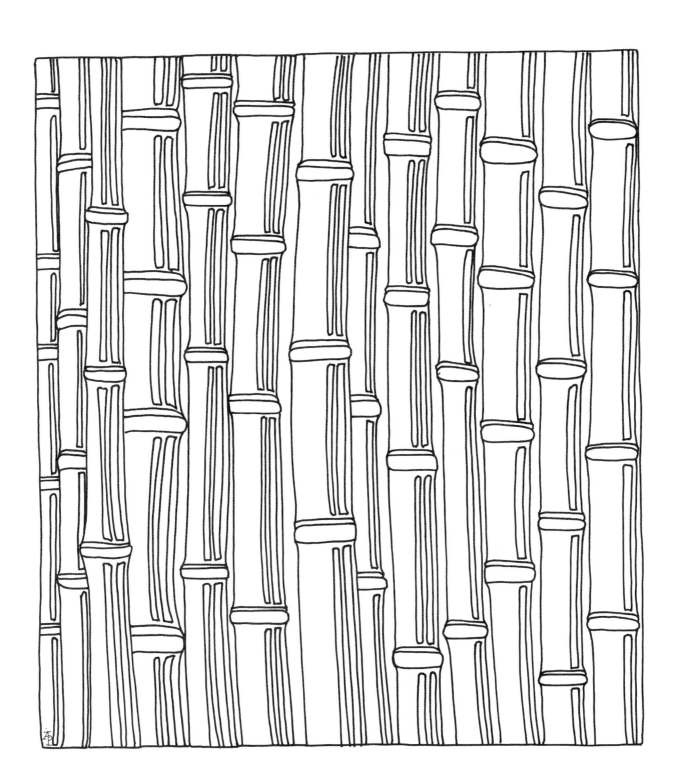

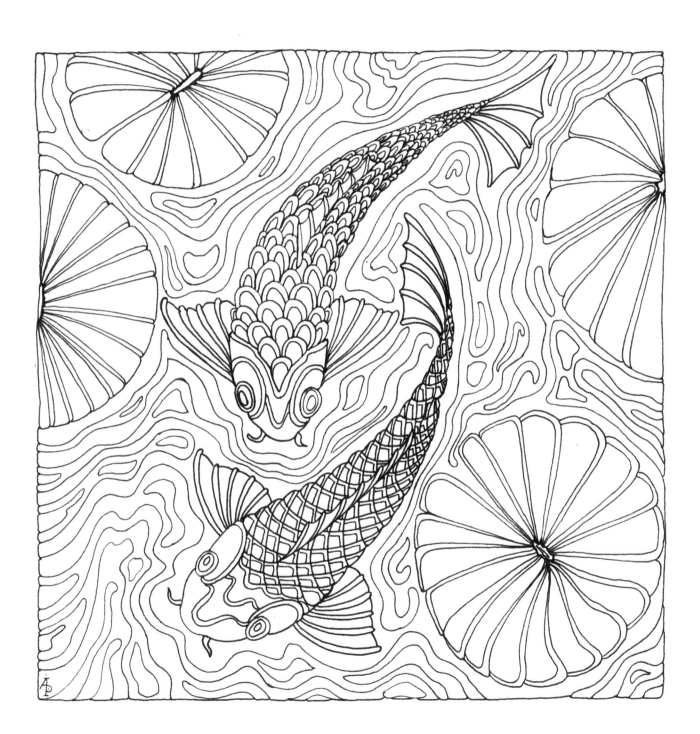

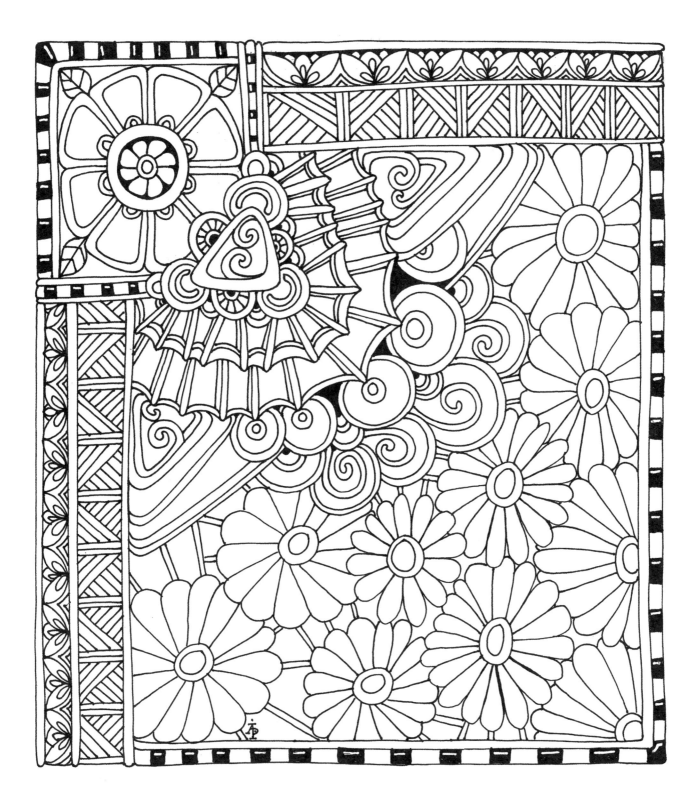

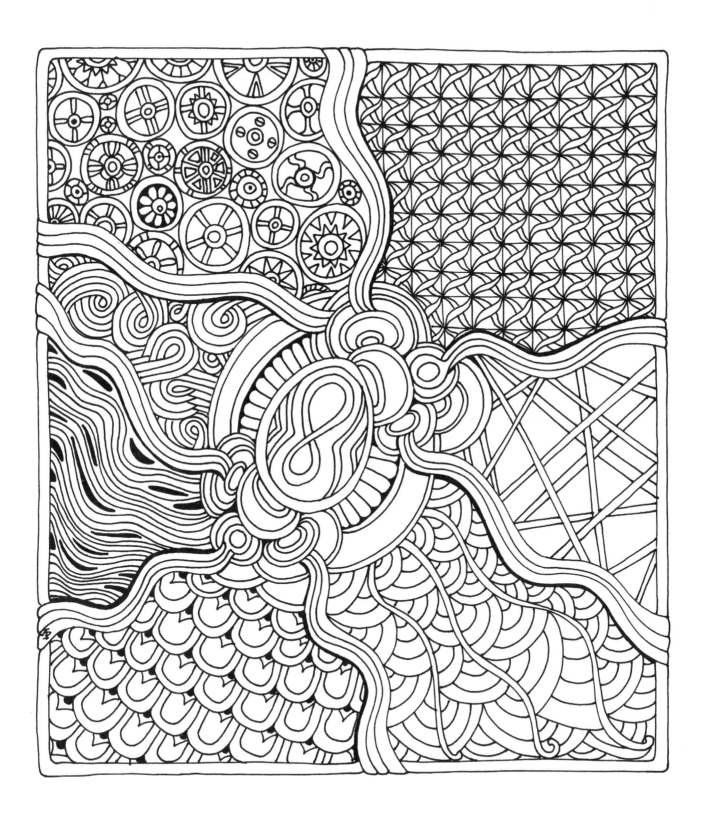

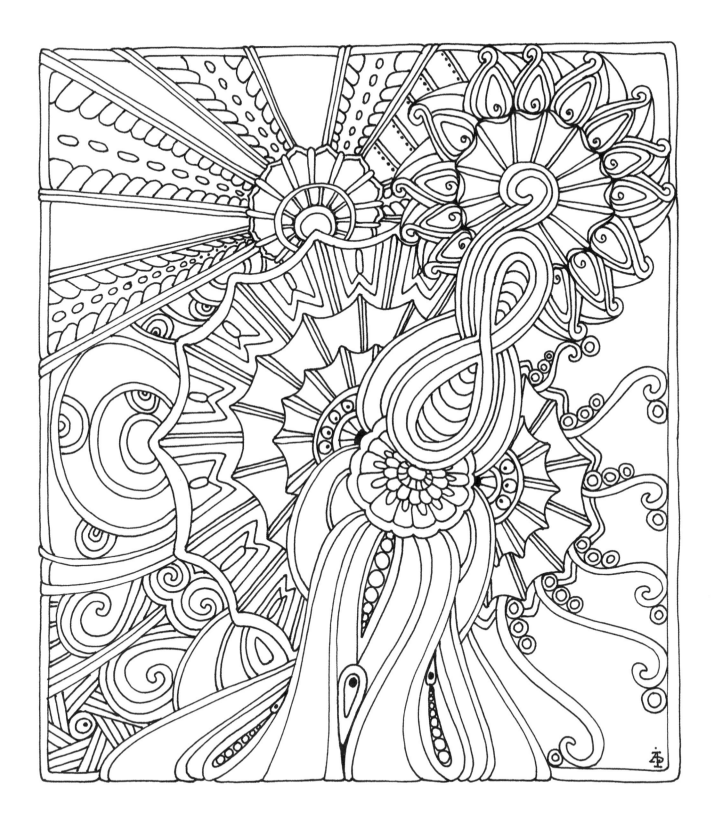

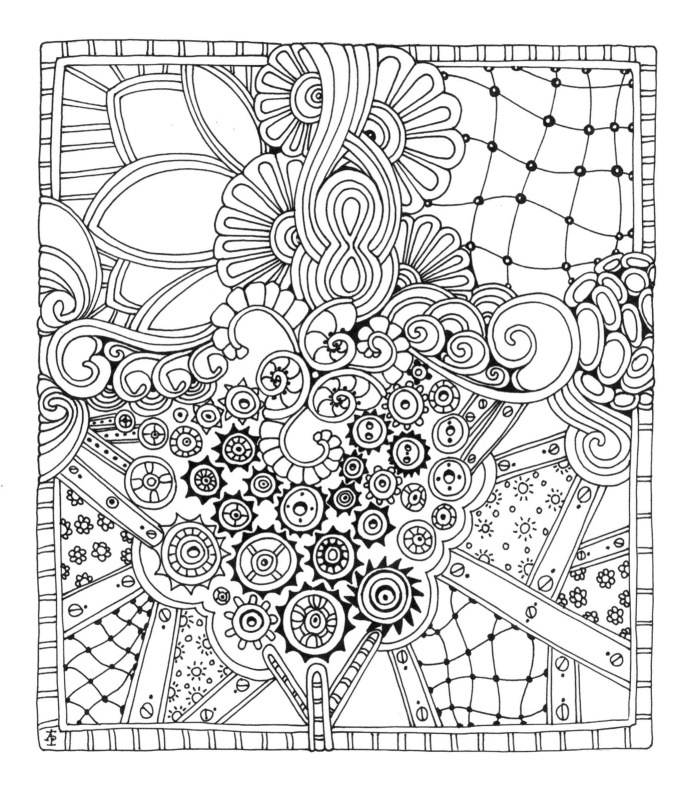

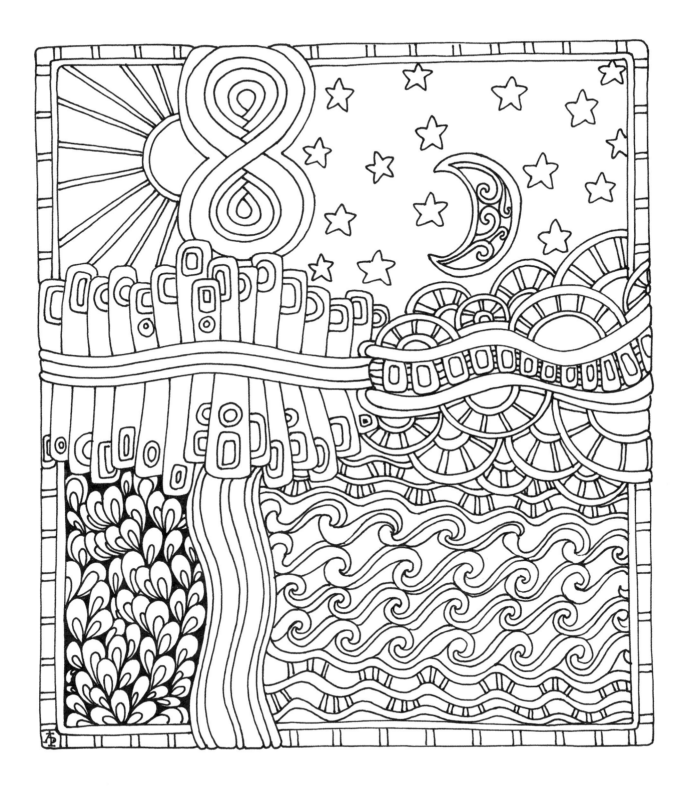

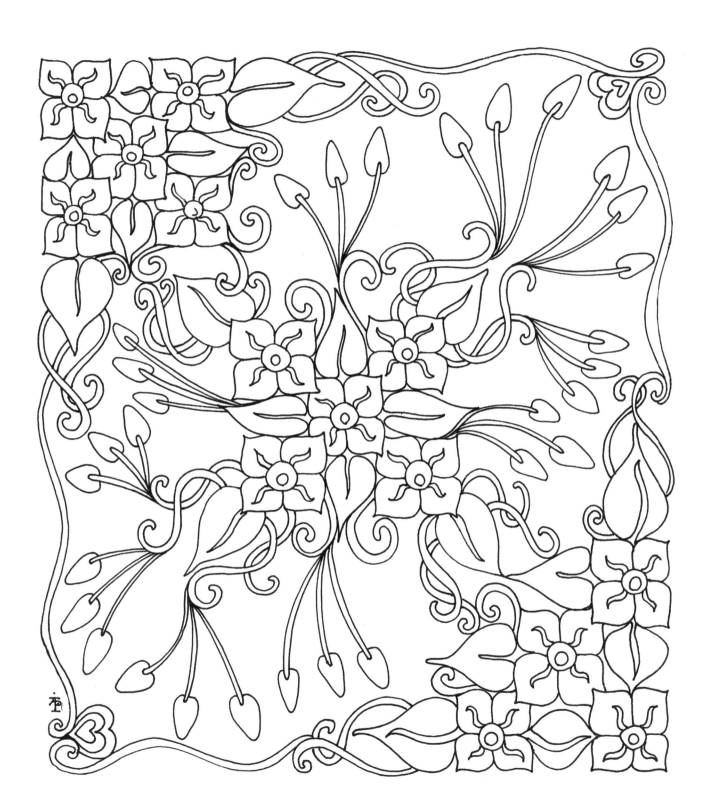

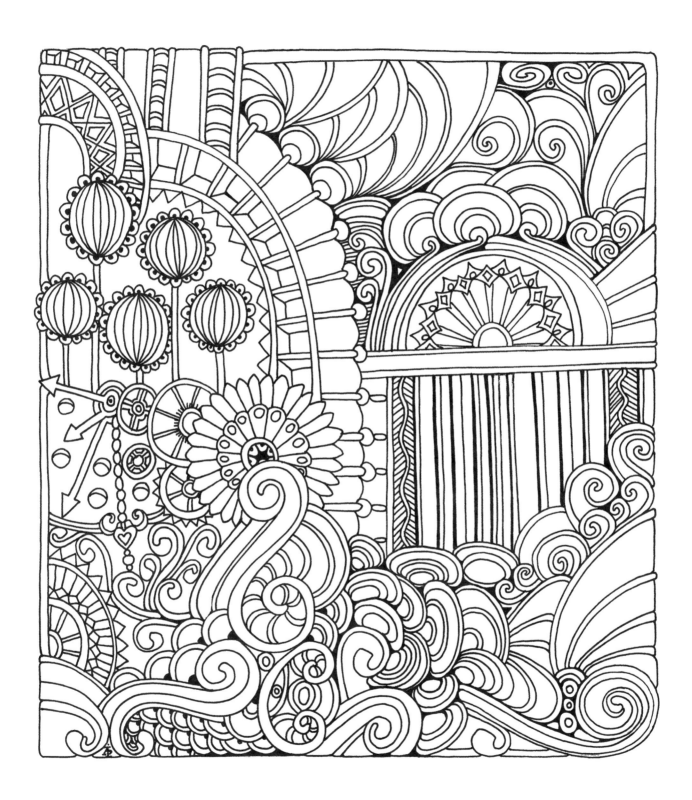

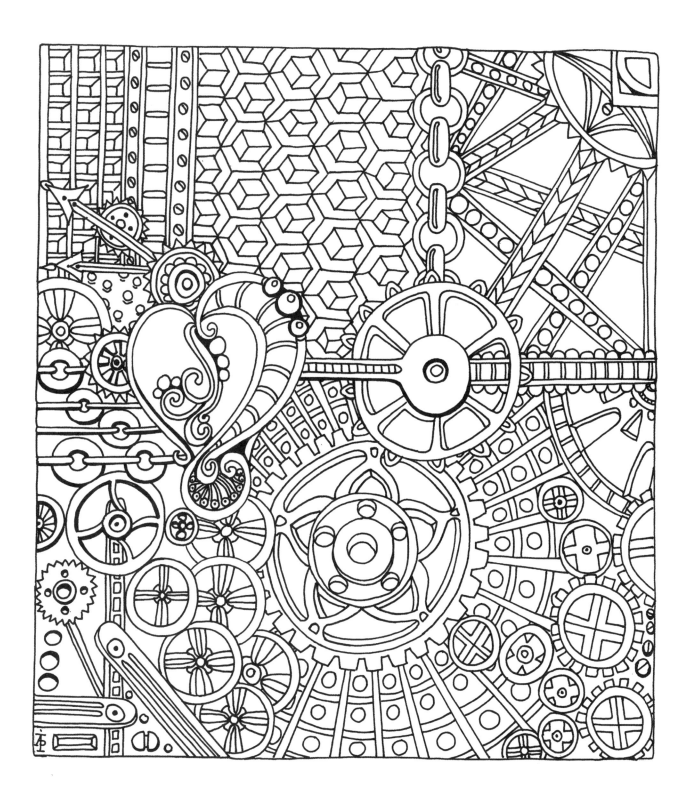

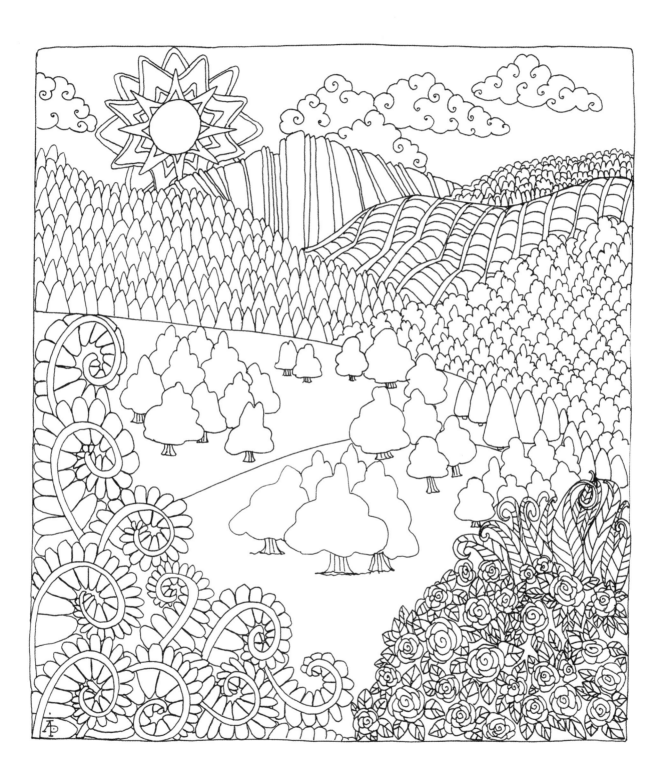

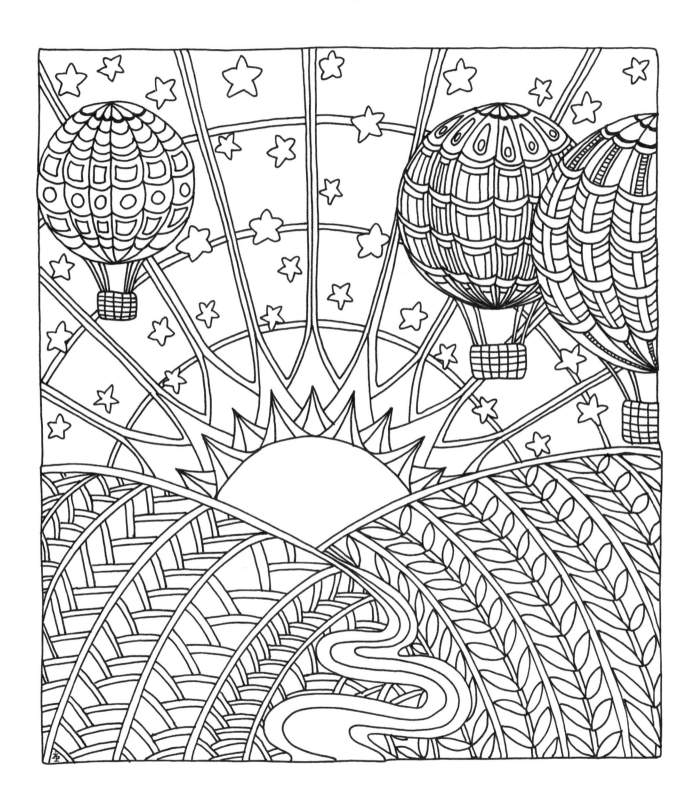

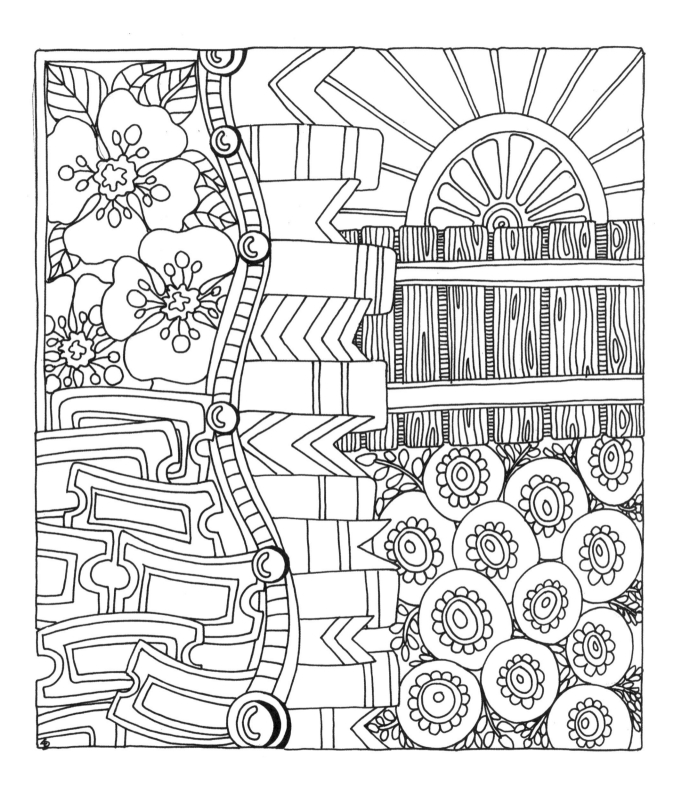

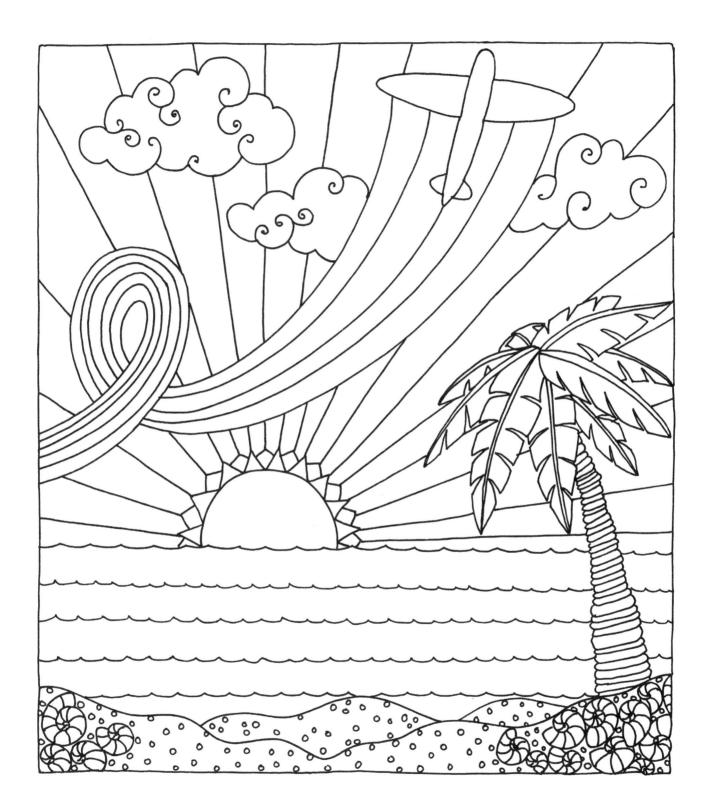

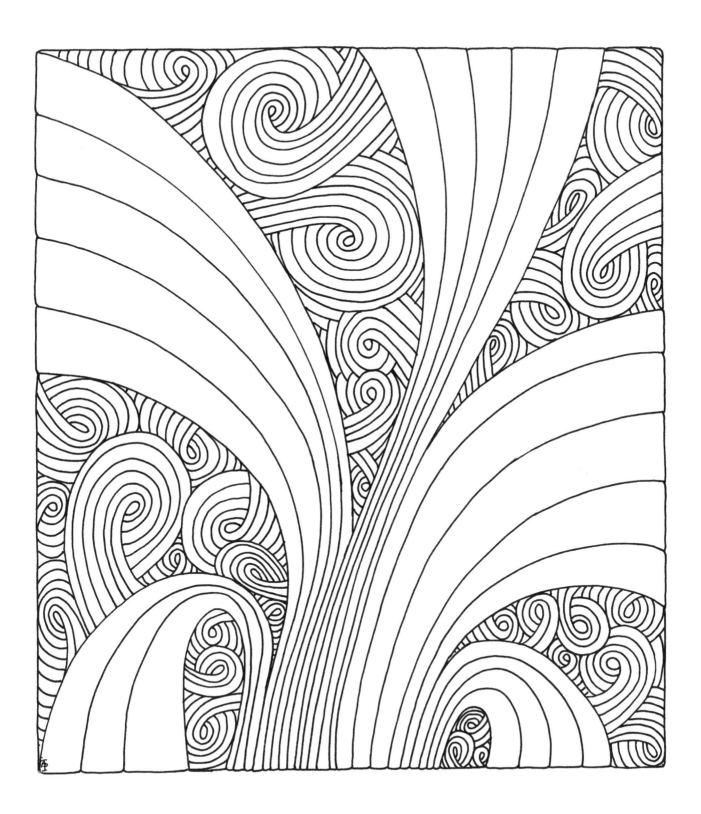

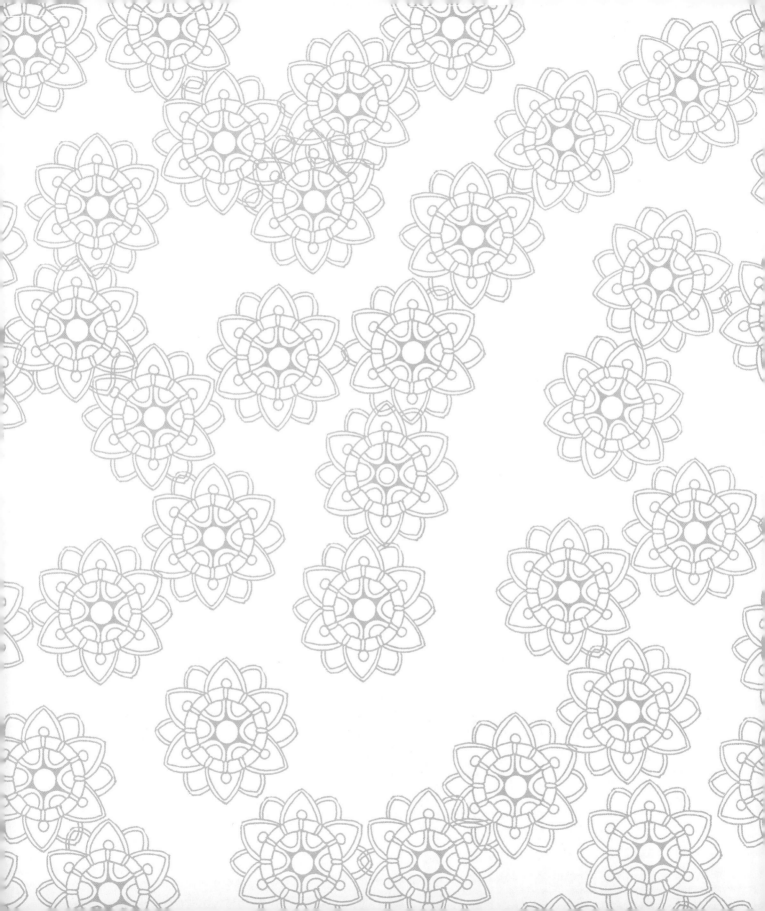

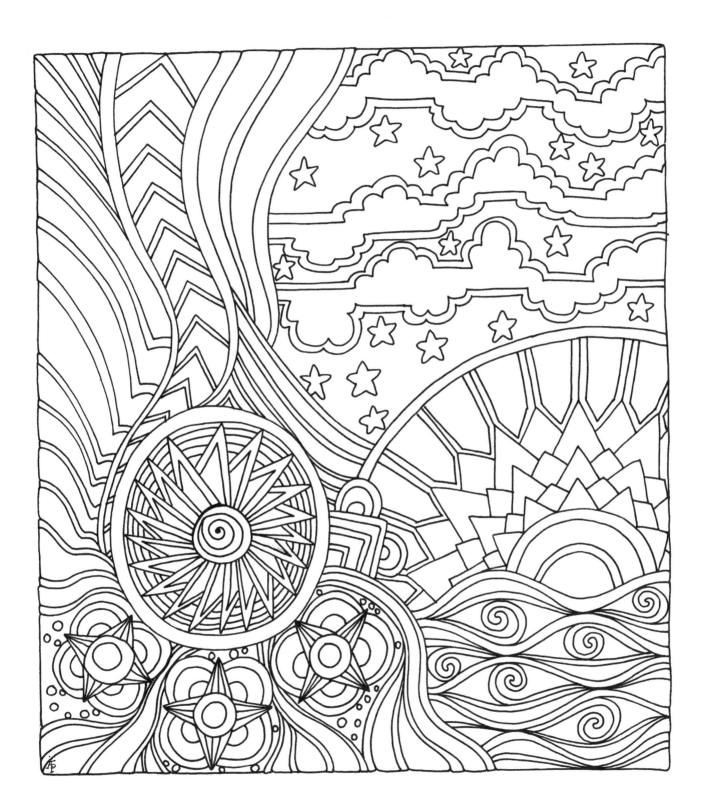

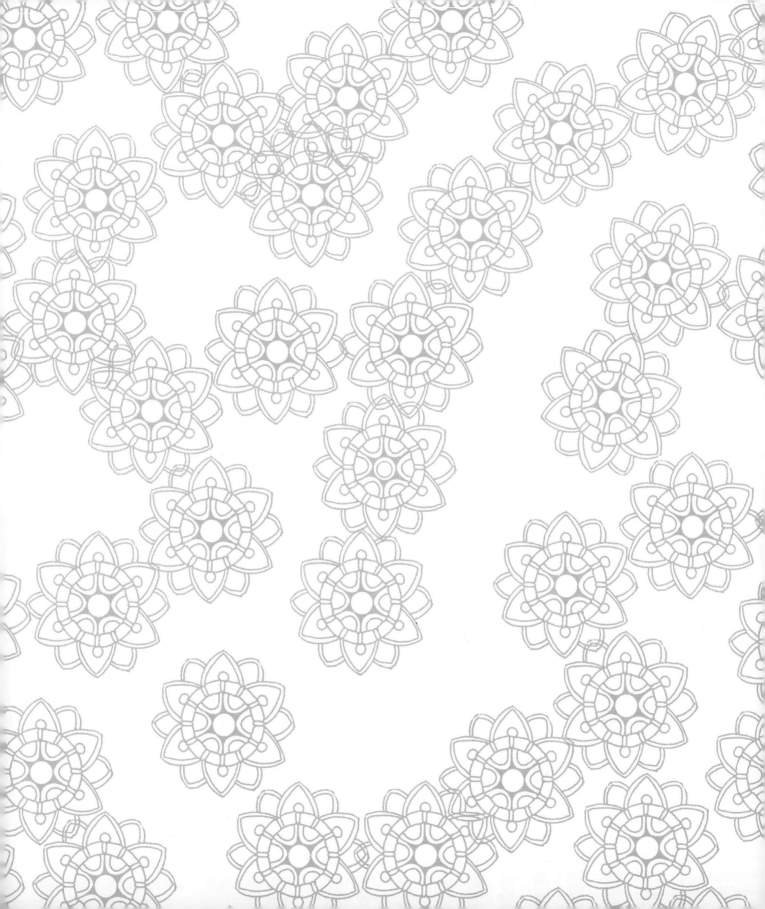

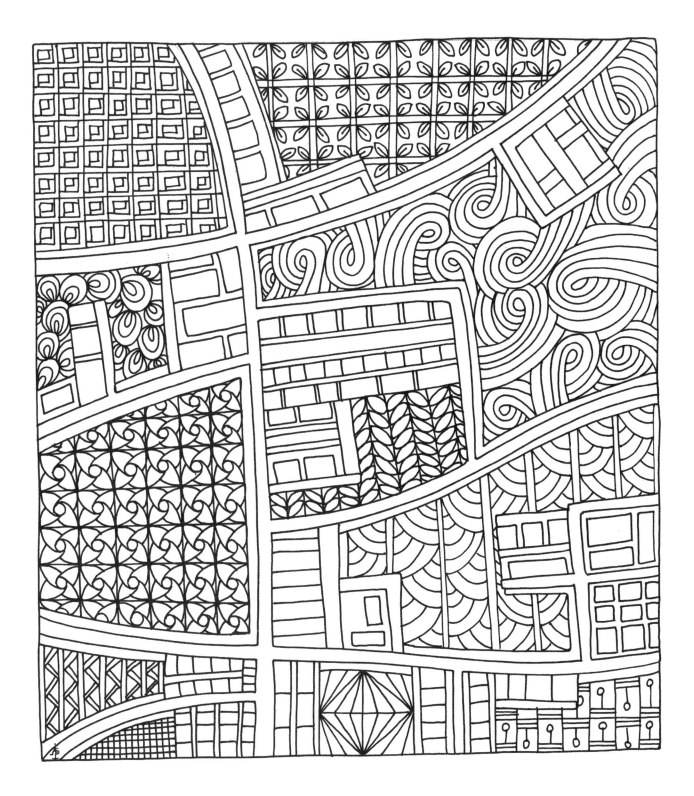

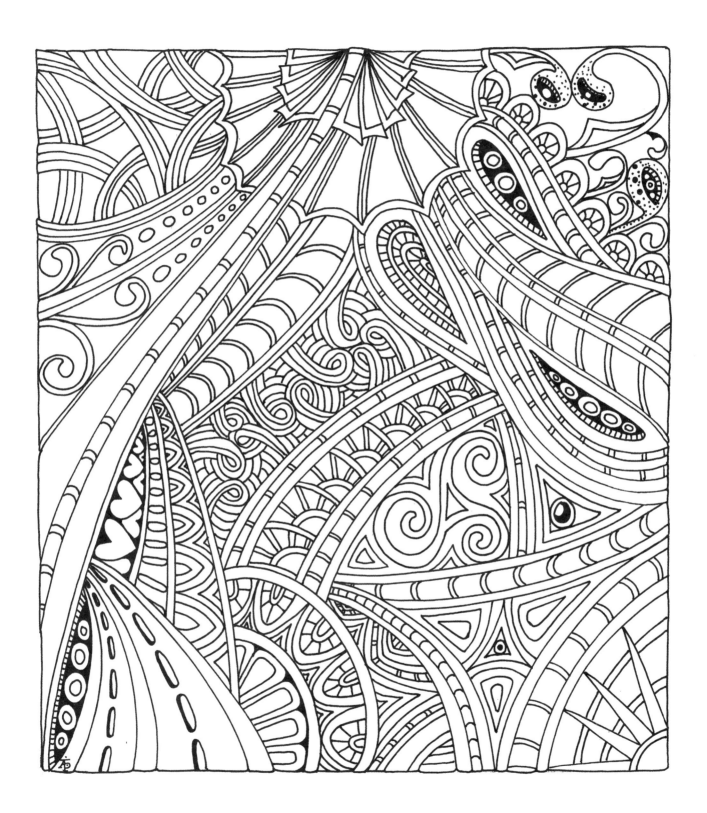

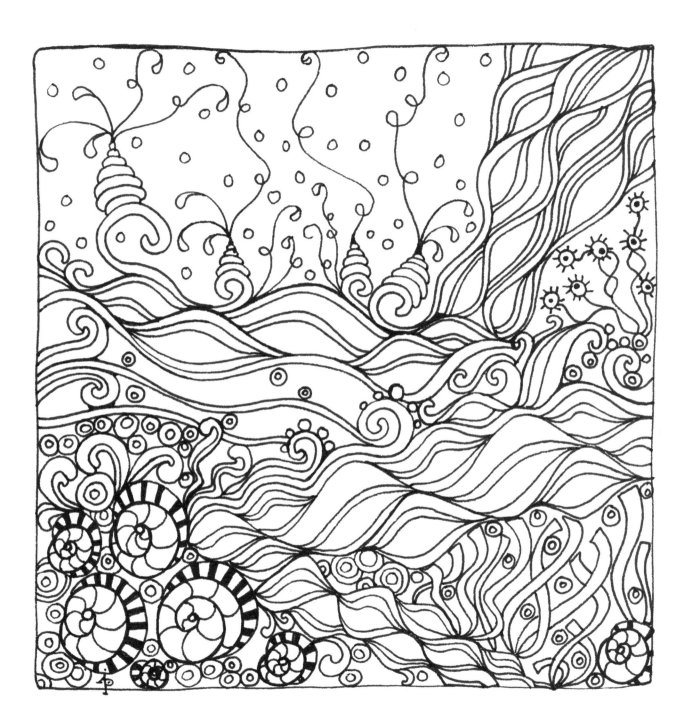

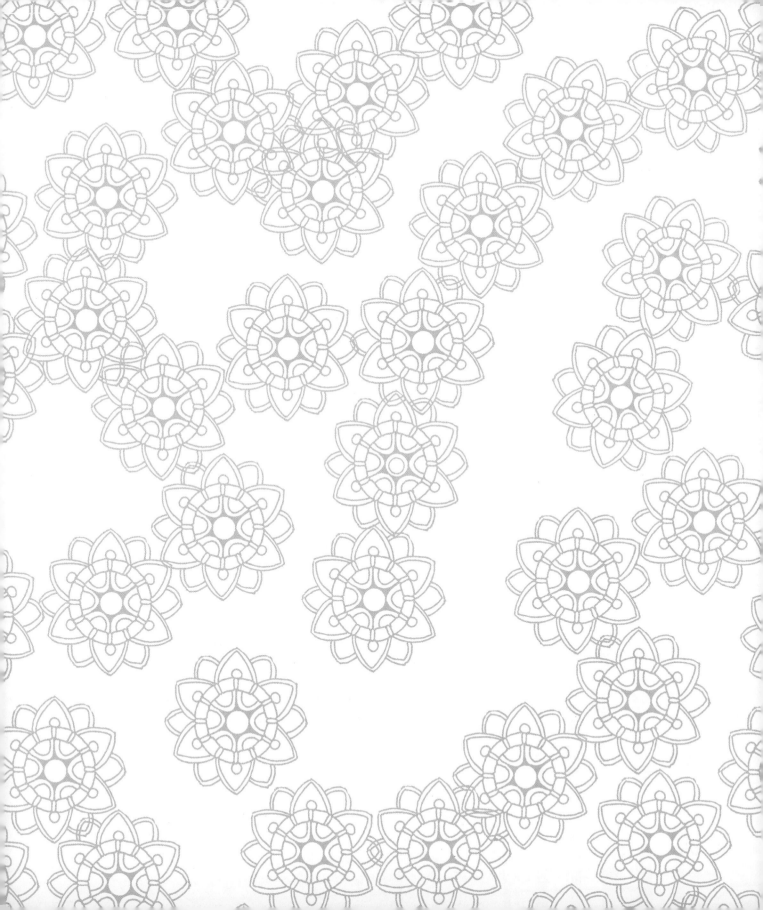